Caught Snapping Photographs III

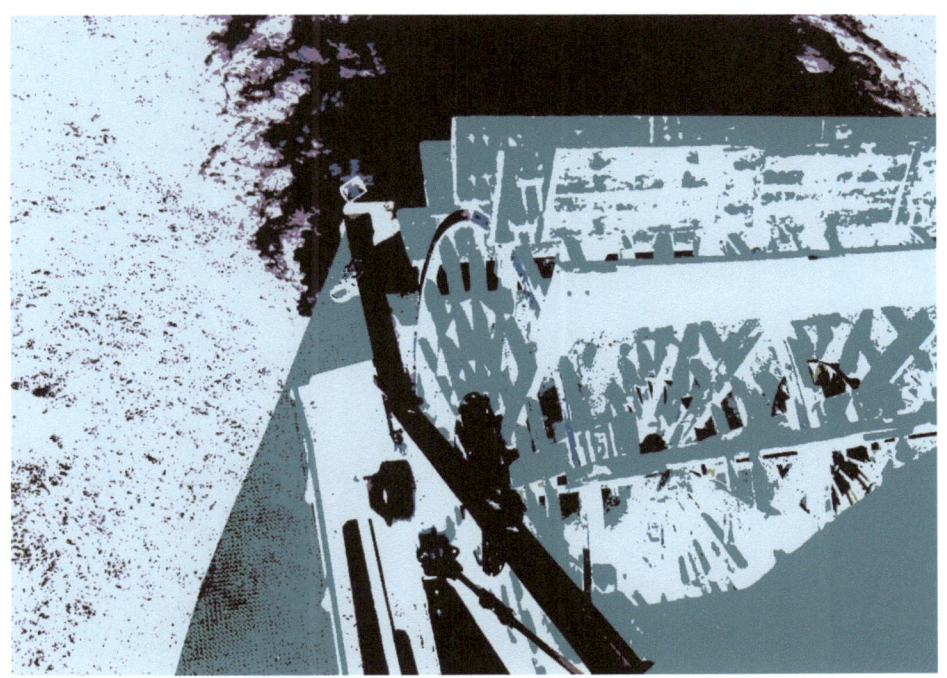

Keith Pepperell

Copyright © 2017 Keith Pepperell

All rights reserved.

ISBN-13: 978-1543104448

ISBN-10: 1543104444

DEDICATION

To my spawn Jack, Alex, and Lydia all of whom have taken a snap or two

ACKNOWLEDGMENTS

Lady Joan Pepperell

Sir Francis Pepperell

Sir Arthur (Don) MacDonald Fowler

Lady Audrey Fowler

All of whom loved photography and were jolly good at it too.

THE IMAGES

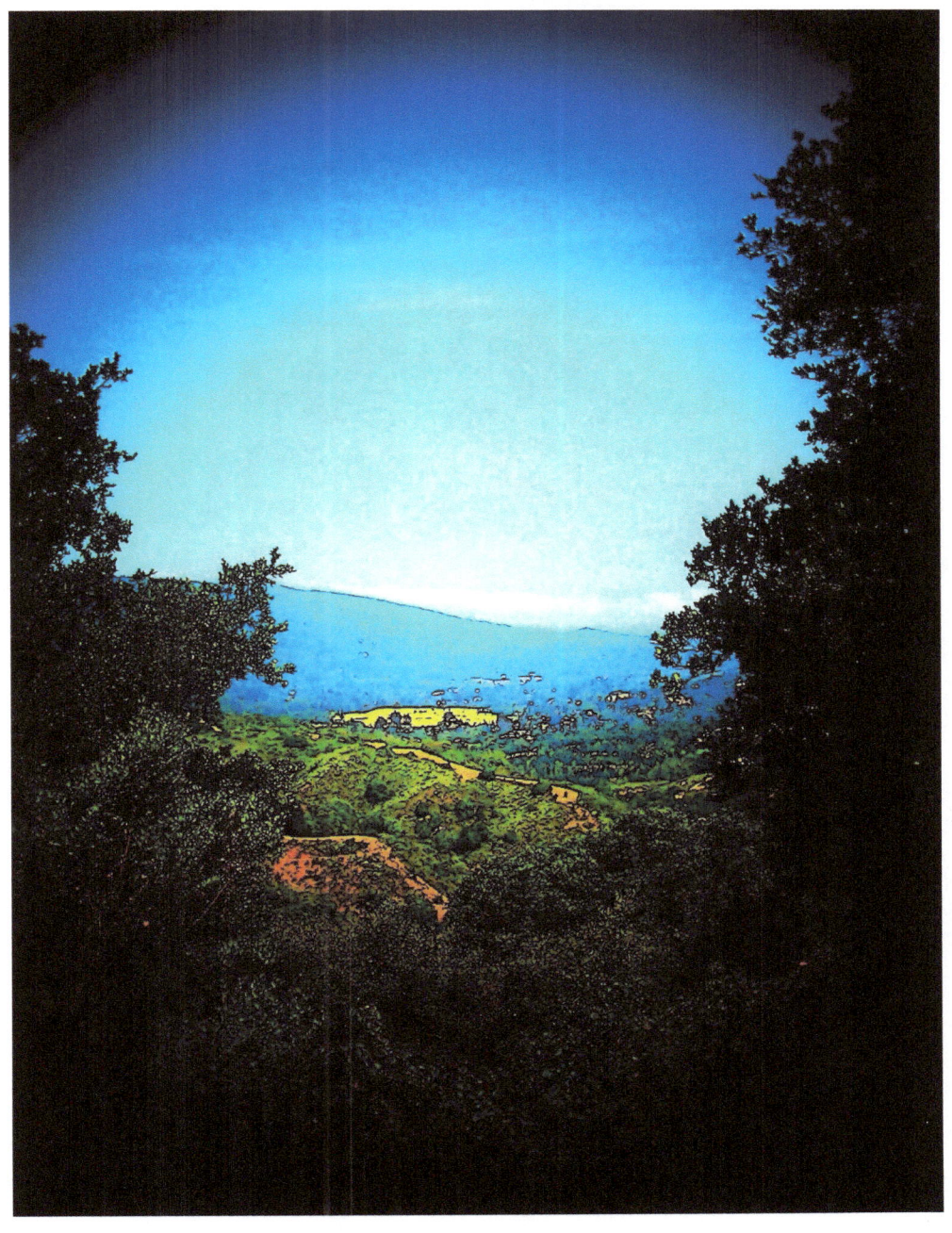

California Morning

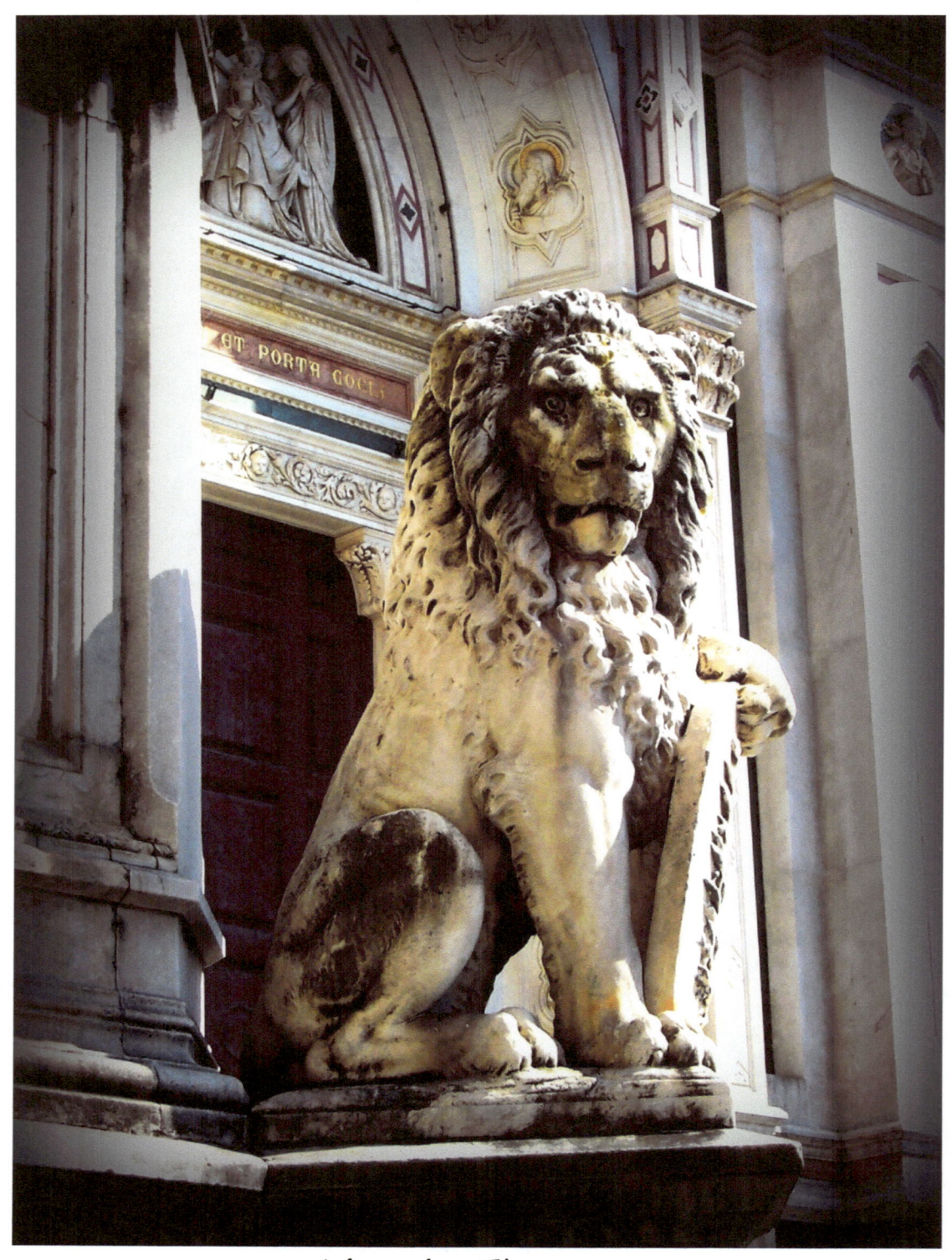

Lion in Florence

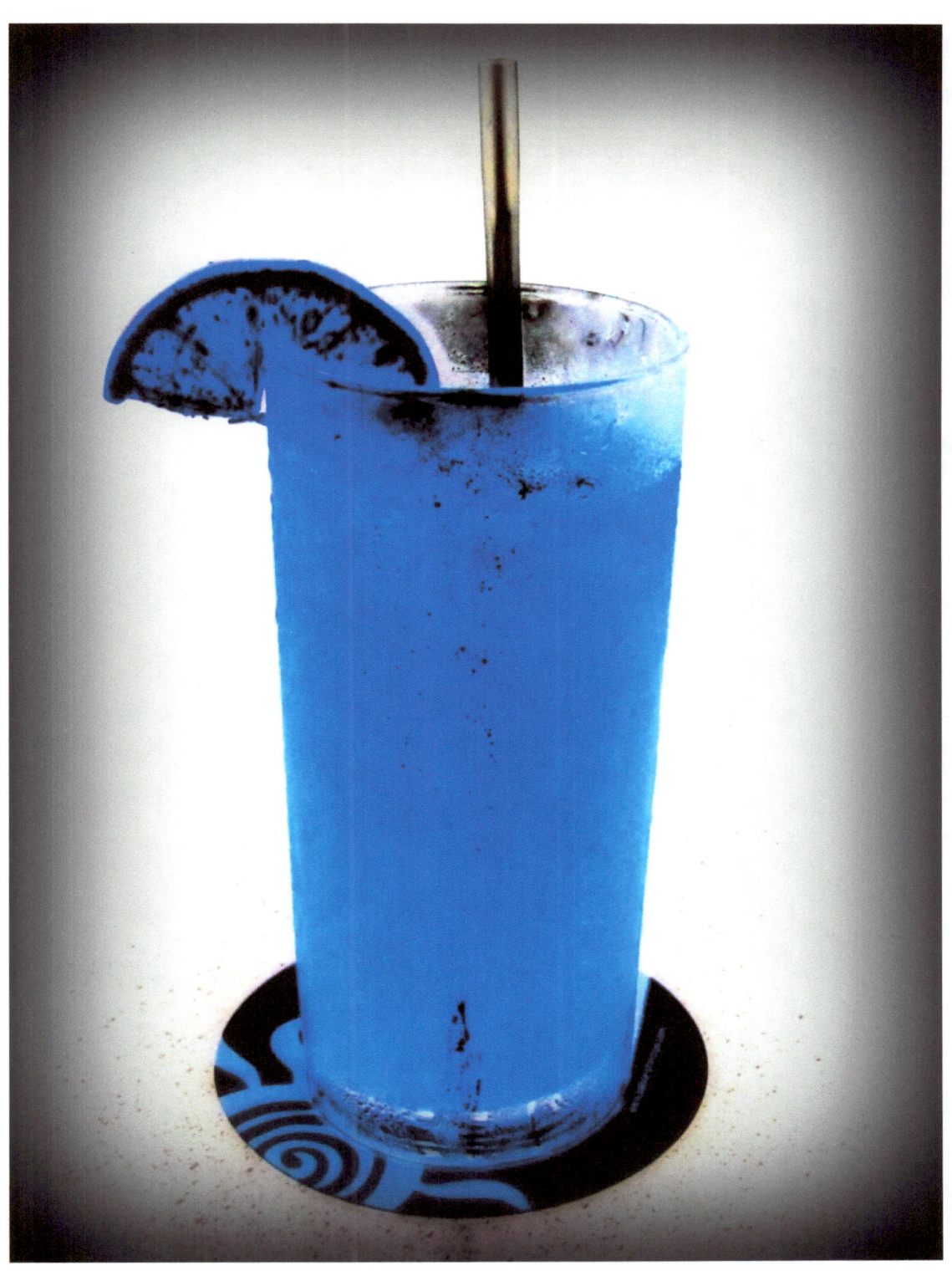

Drinking Away The Blues

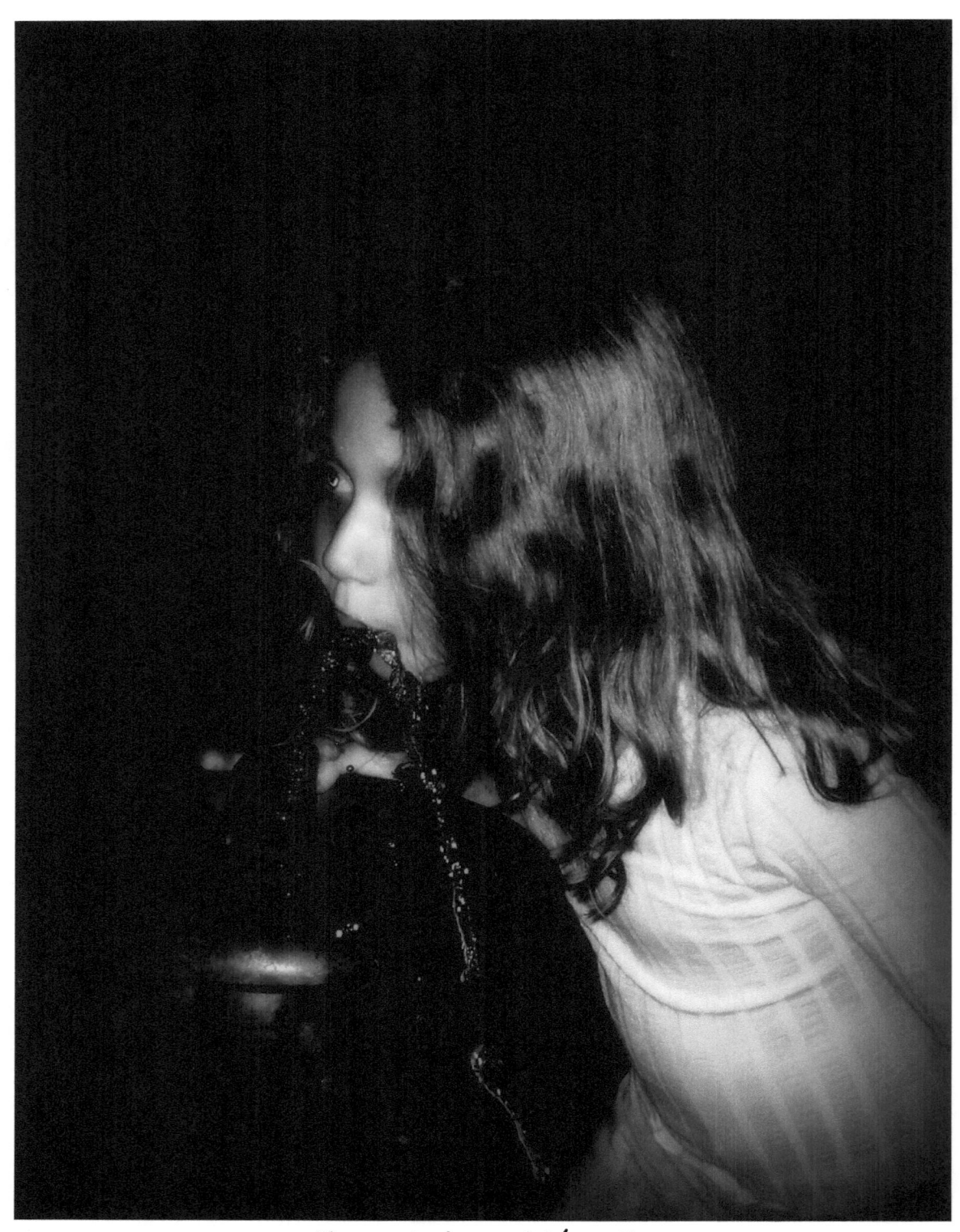

Fountain of Youth

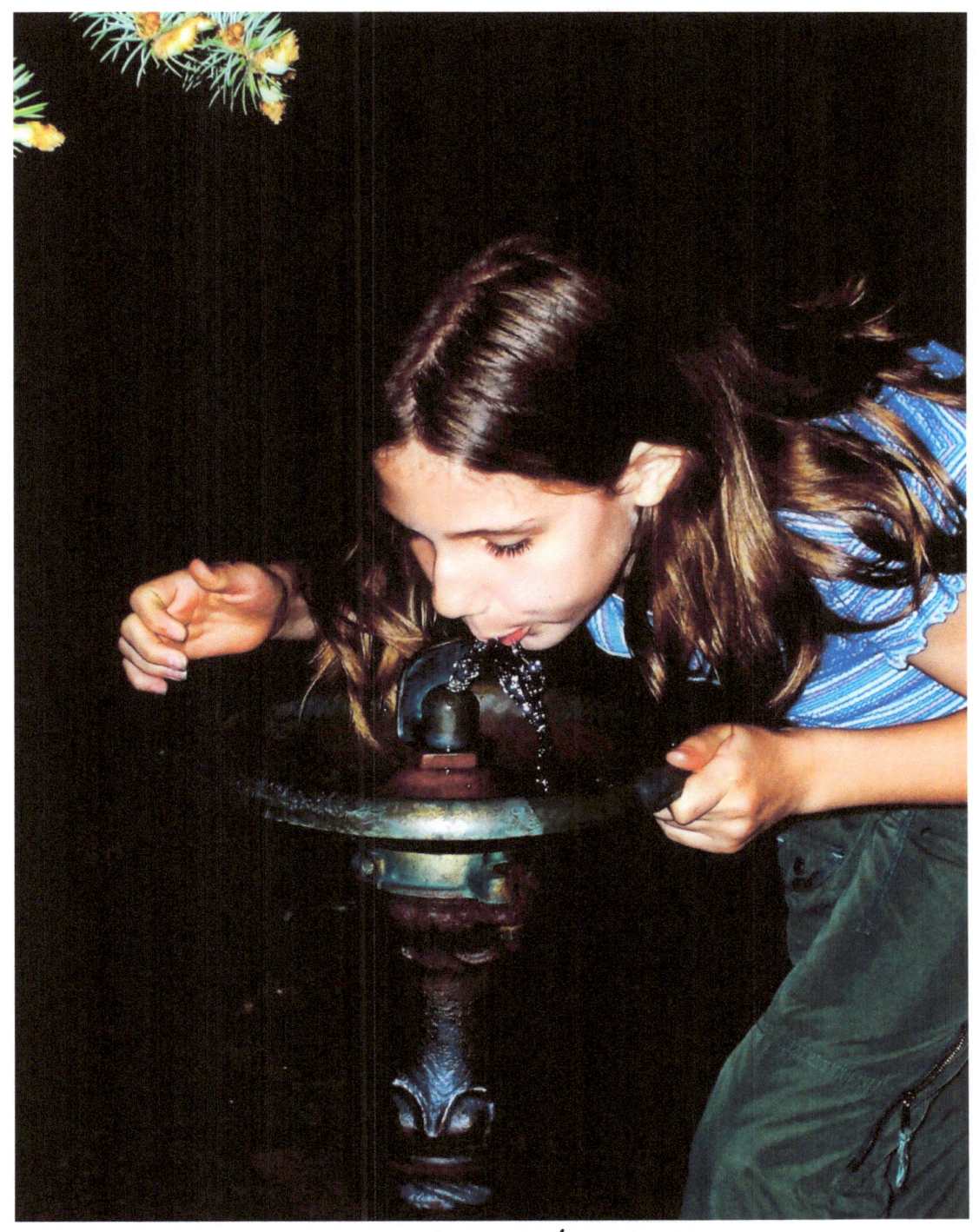

Fountain of Youth II

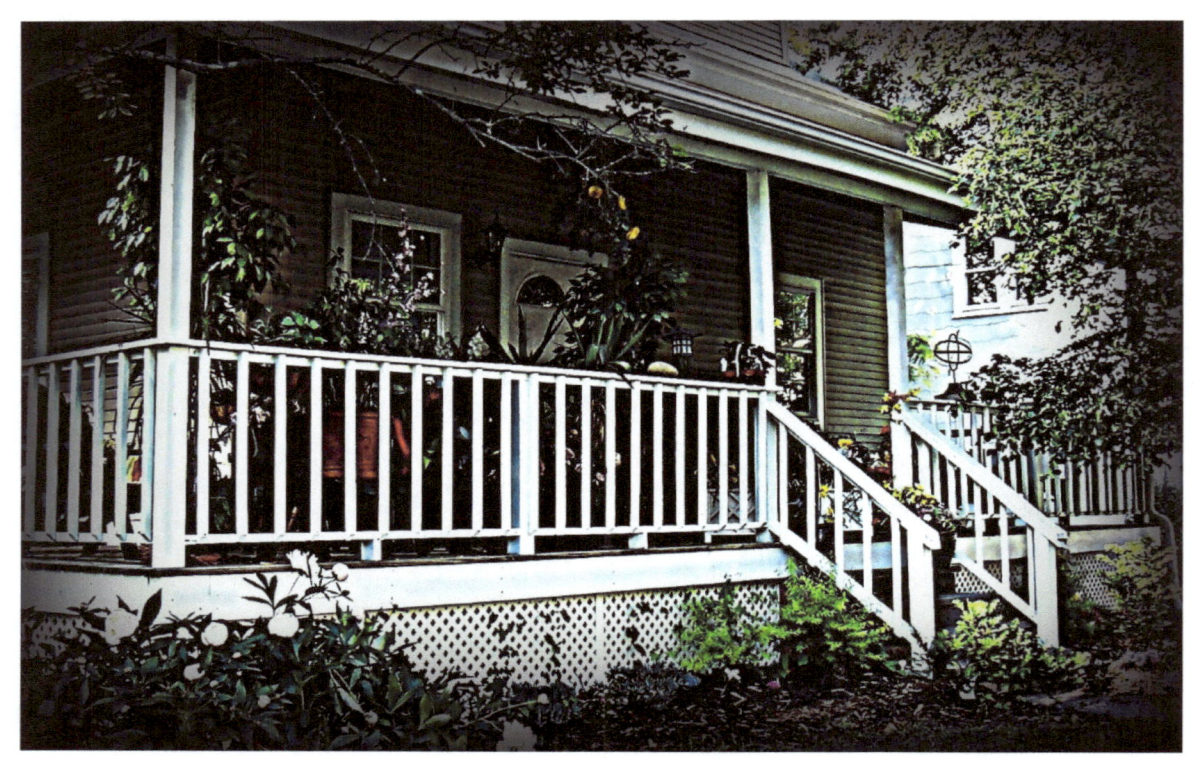

Lincoln Avenue Porch

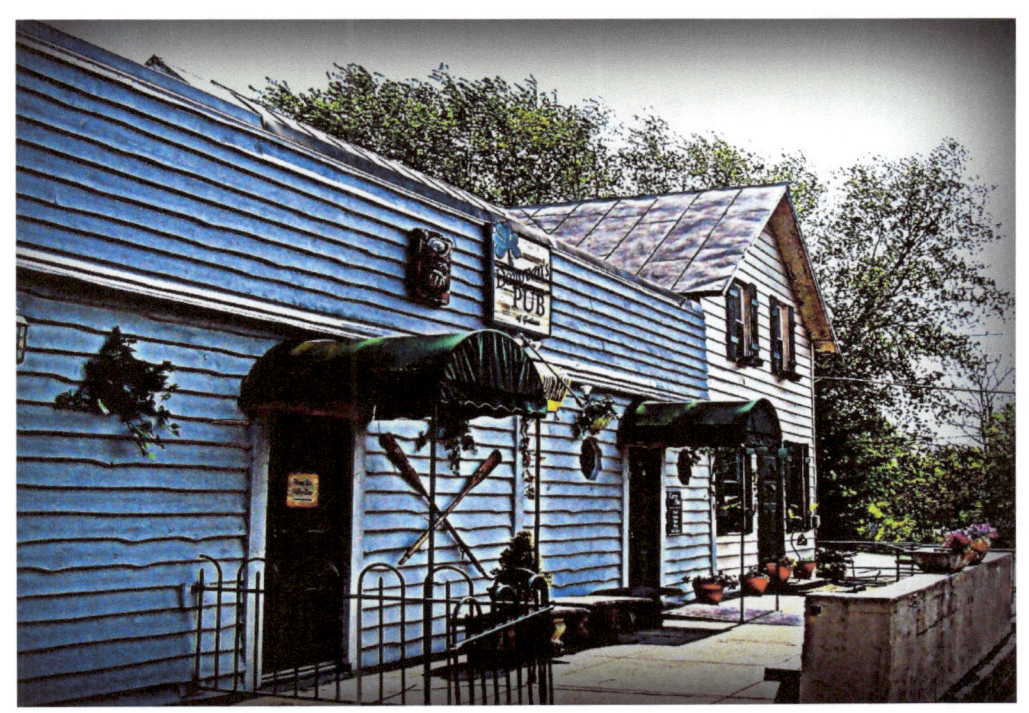

Donovan's Pub, Galena, Ohio

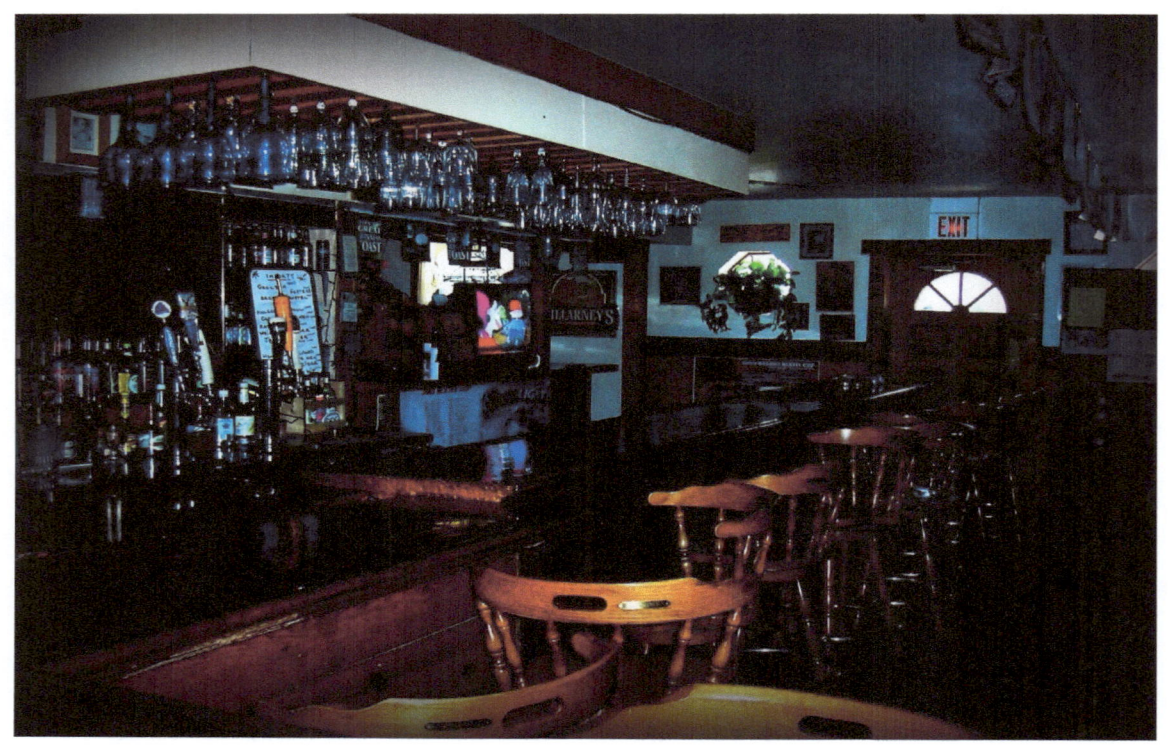

Donovan's Pub

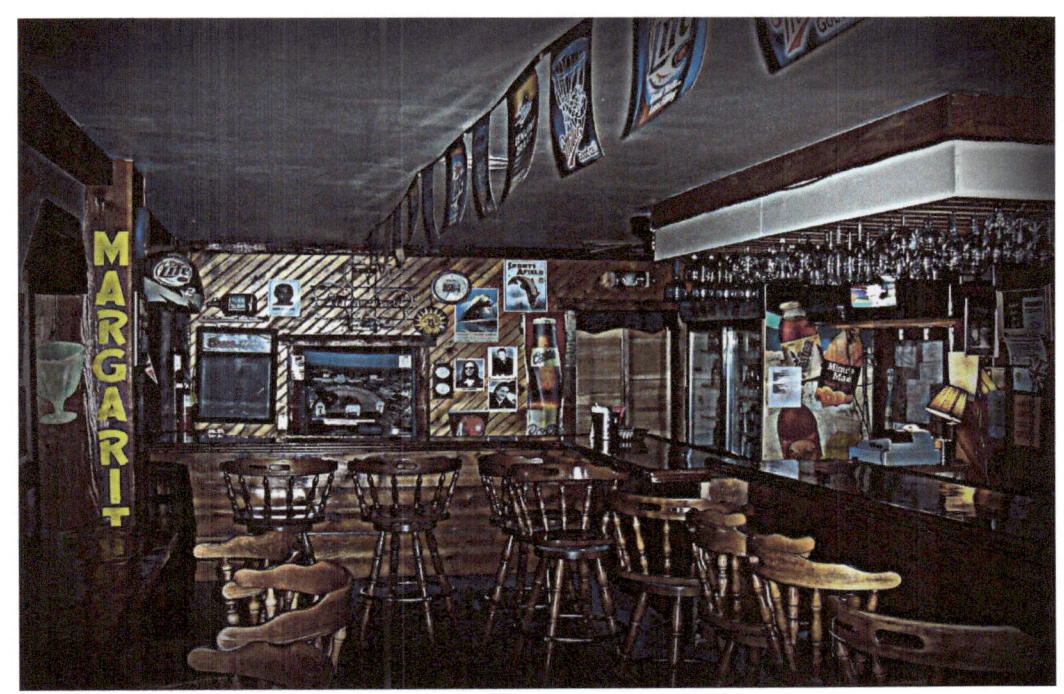

Donovan's Pub

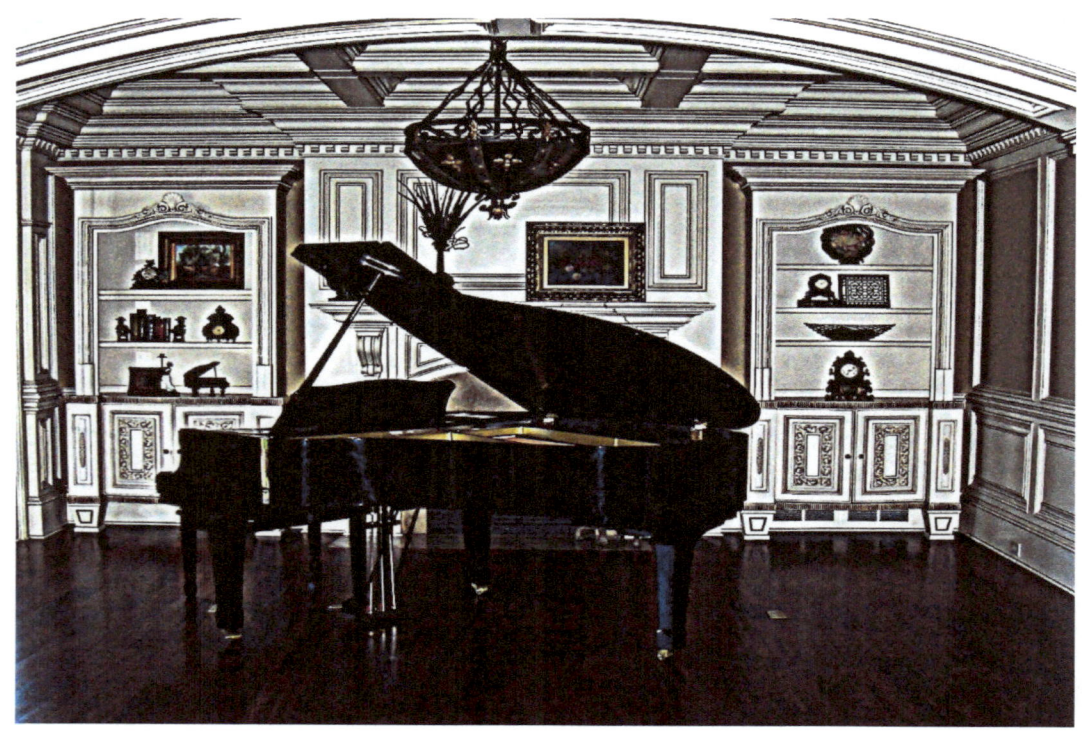

Music Room in Georgia

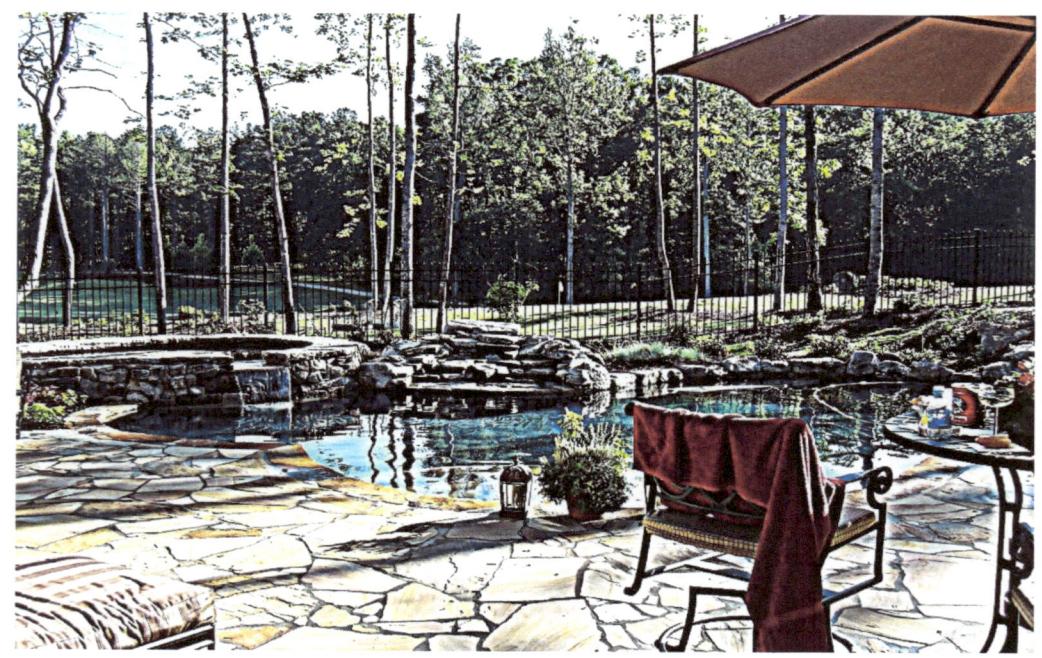

By the Pool in Georgia

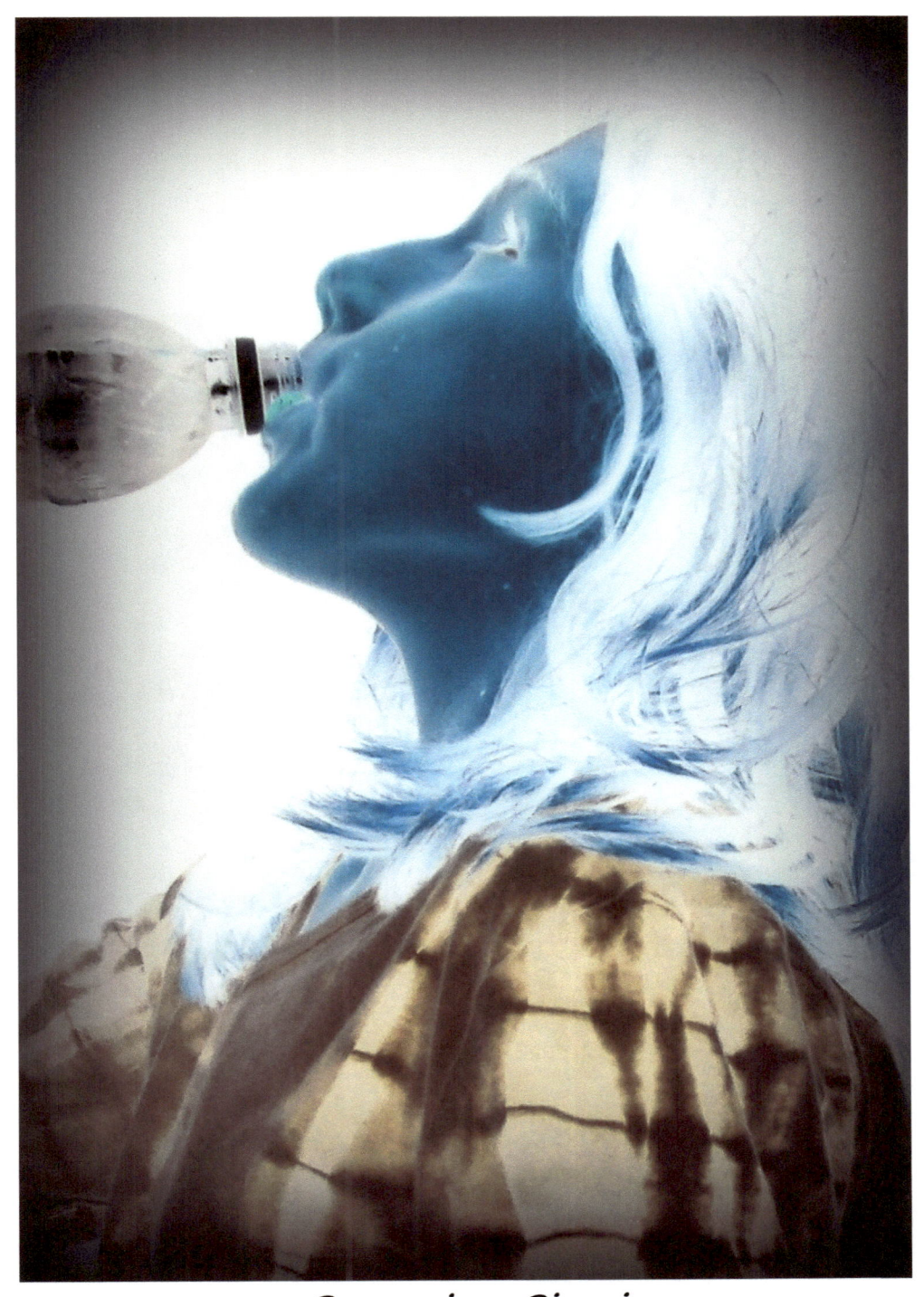

Snapping Sipping

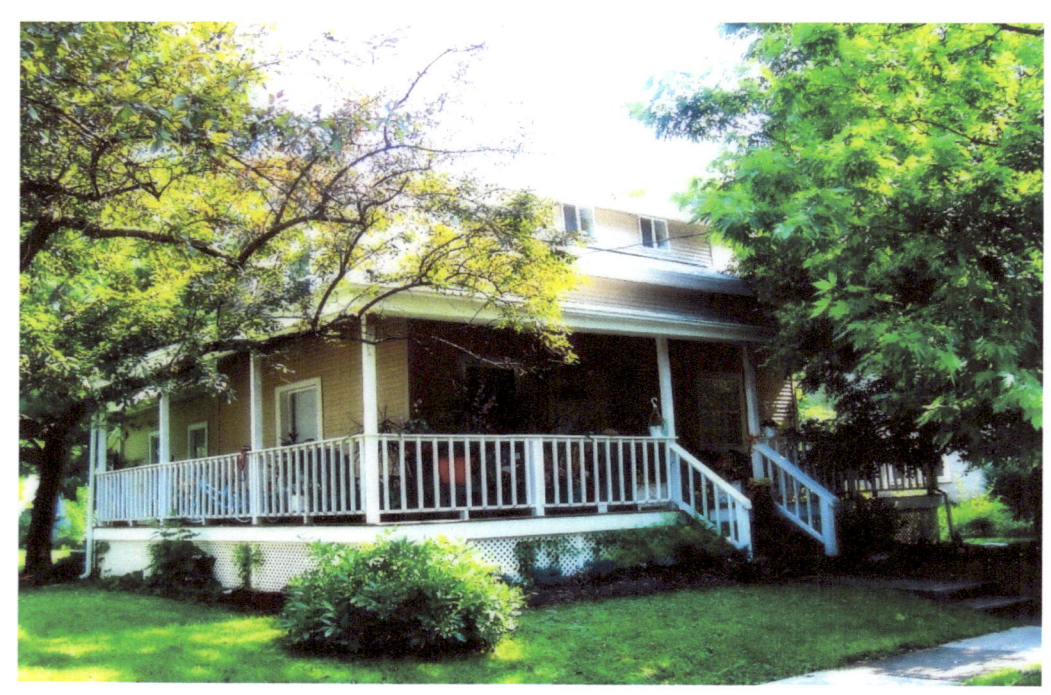
Lincoln Street House, Westerville, Ohio

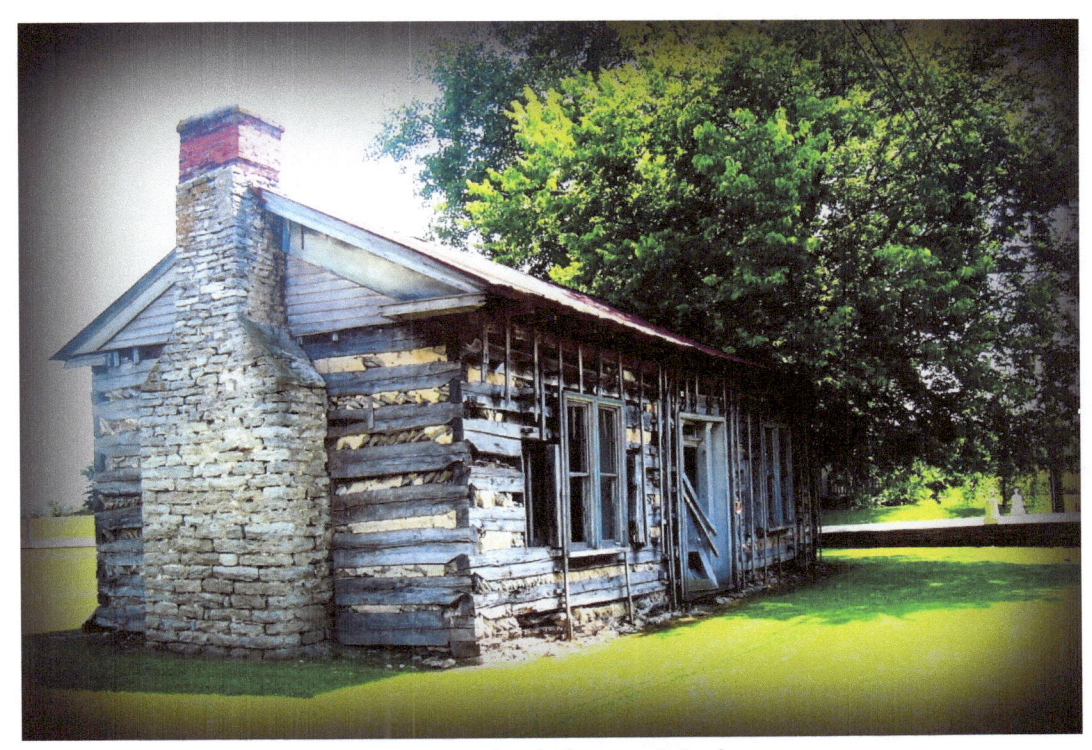
Log Cabin, Ohio

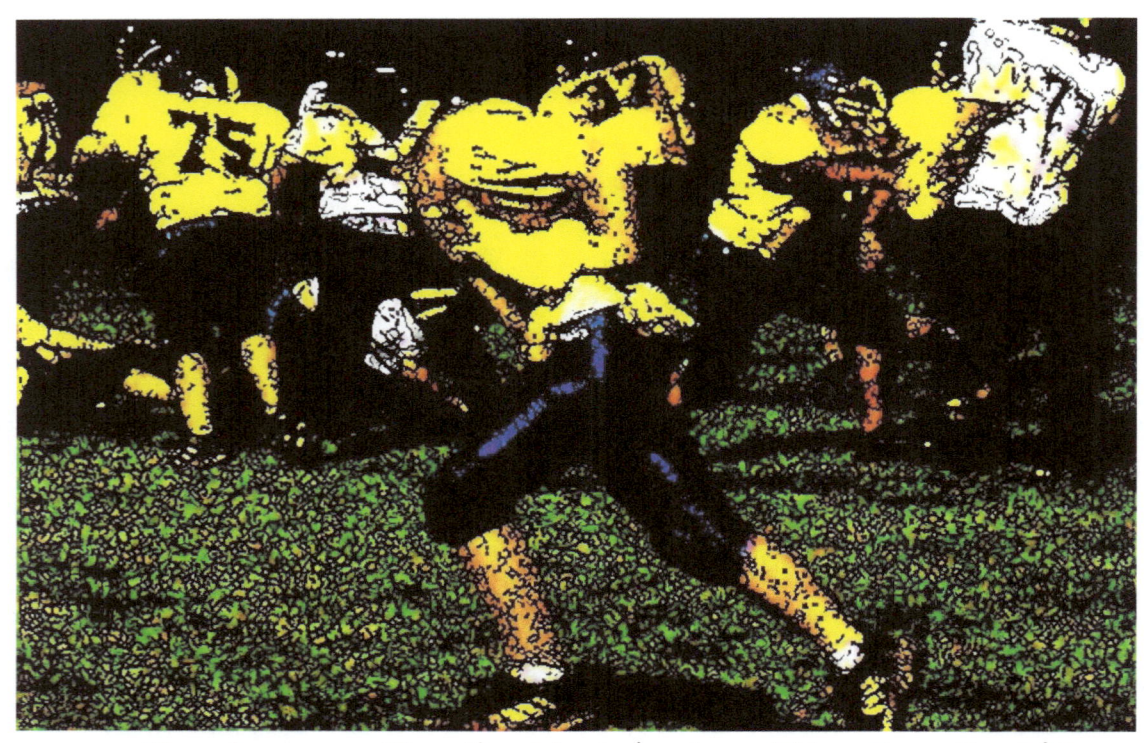

Freshman Football, Westerville South HS

Night Game

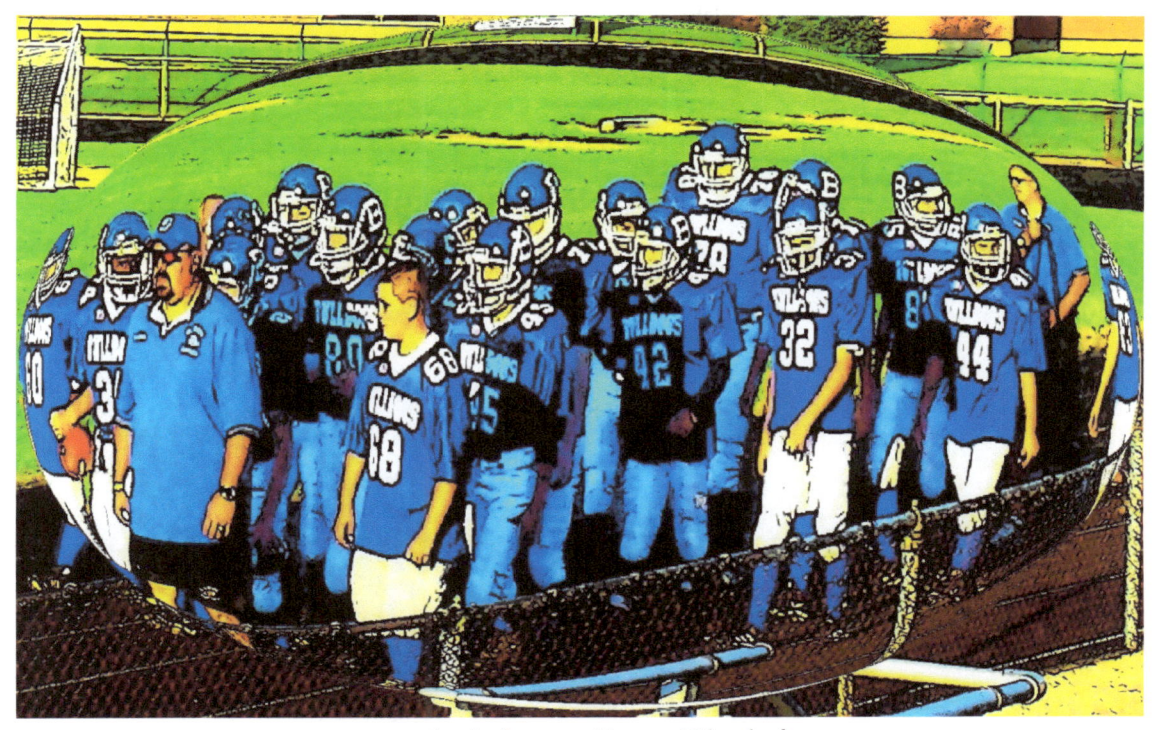

Taking the Field

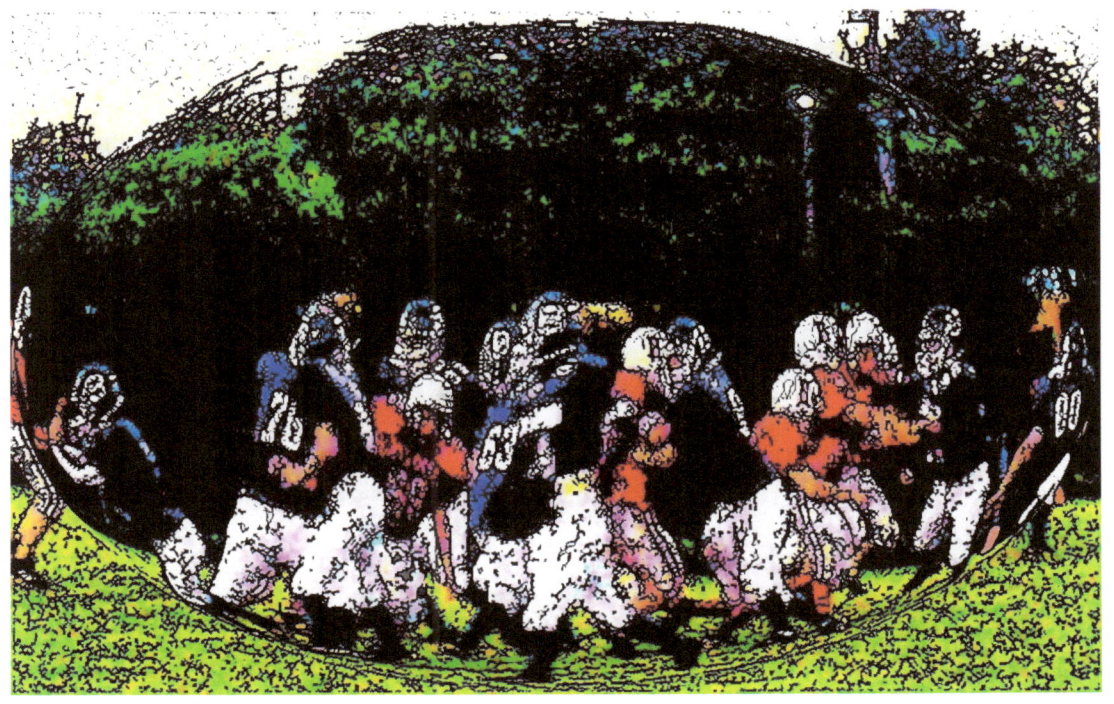

Game Time

Ohio River Paddle Boat

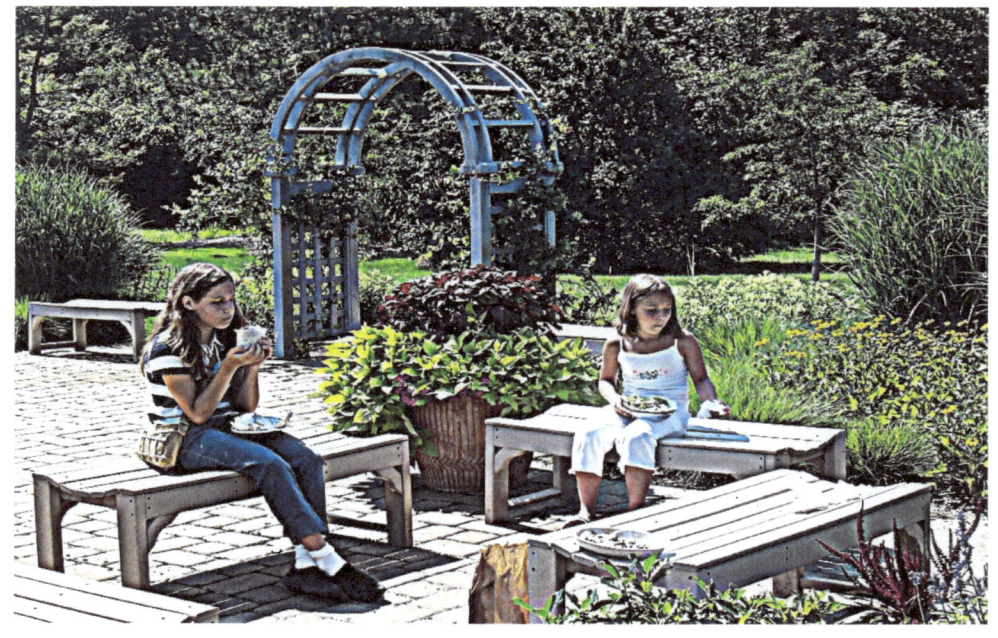

Lunch in the Park

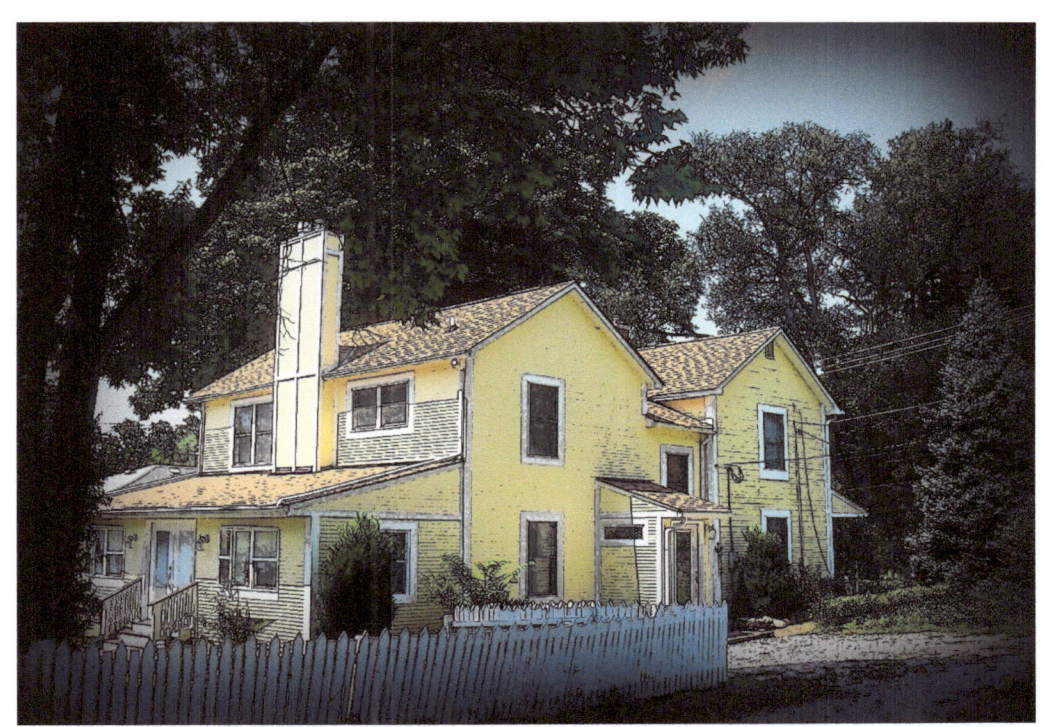

The Homestead

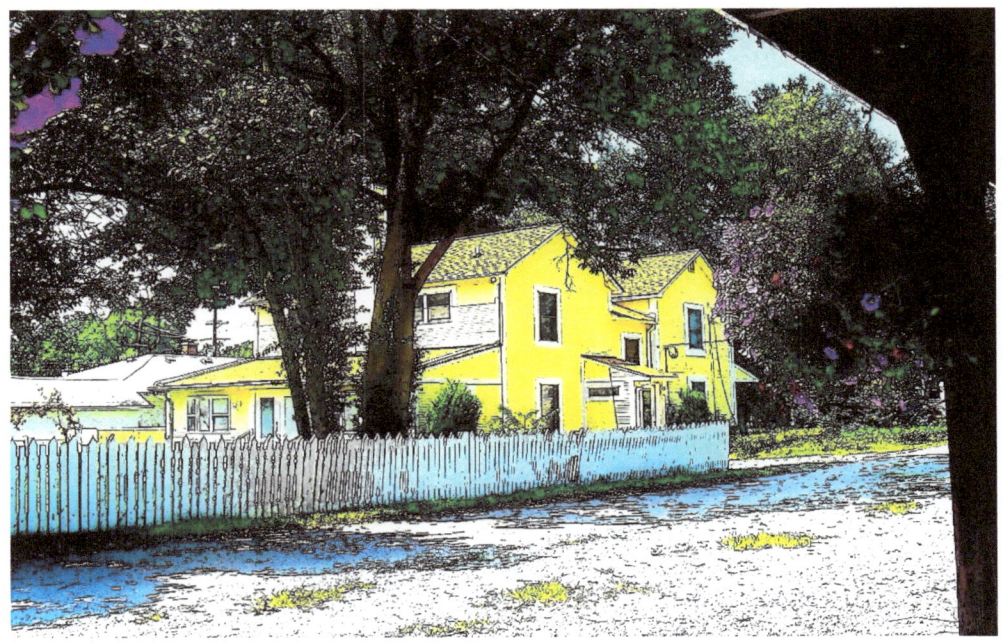

Homestead II

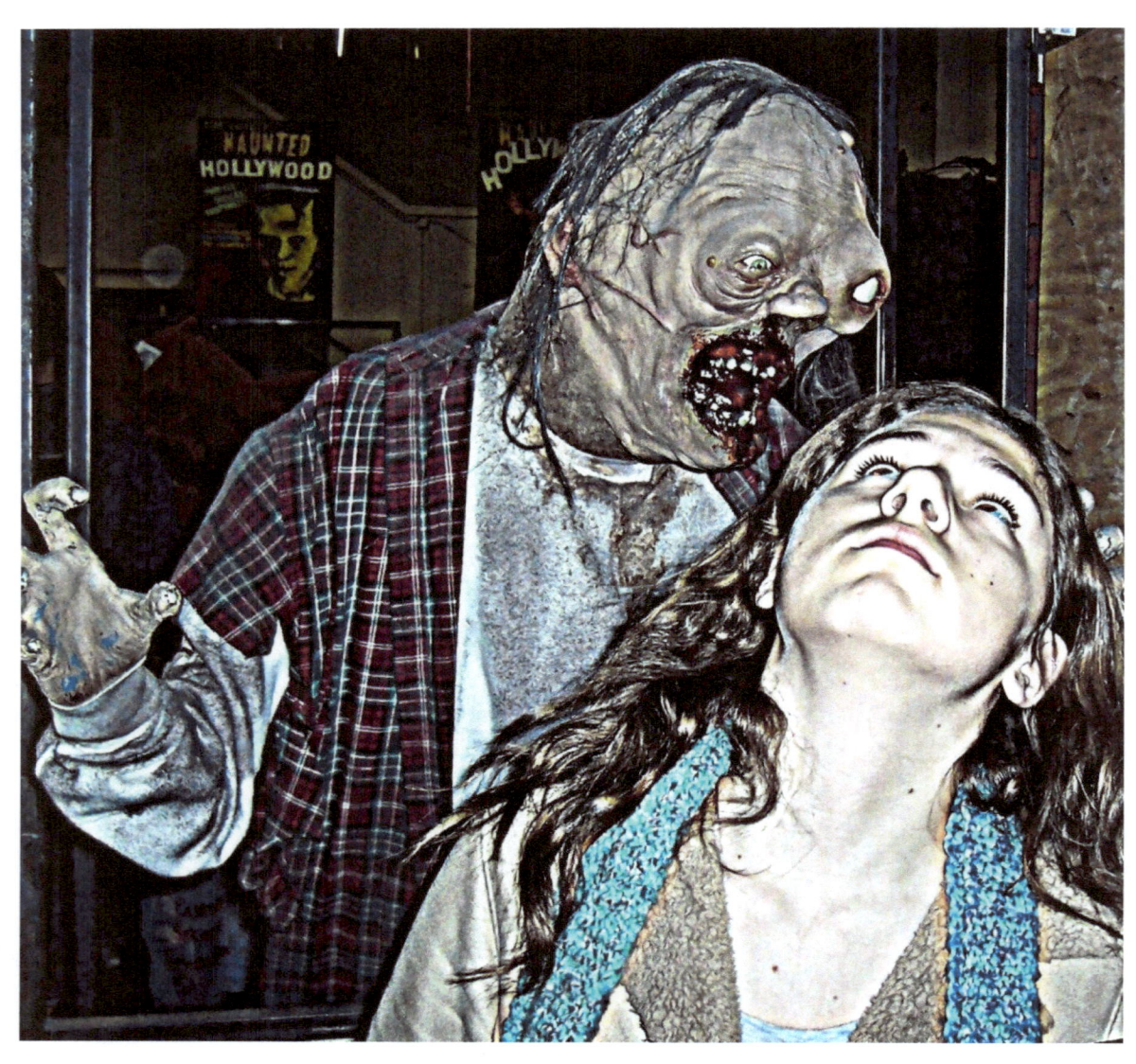

Attack of the Beast

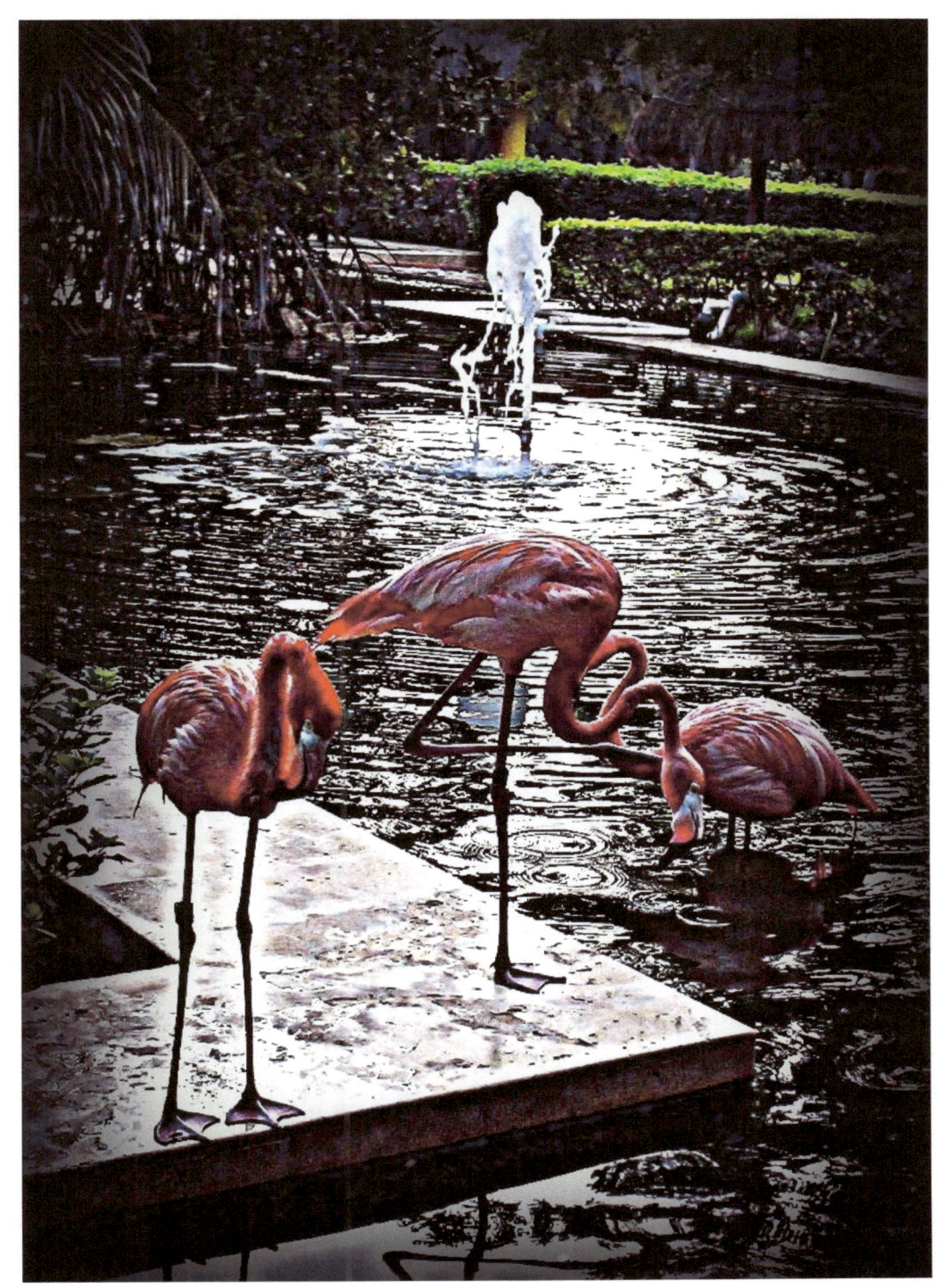

In the Pink

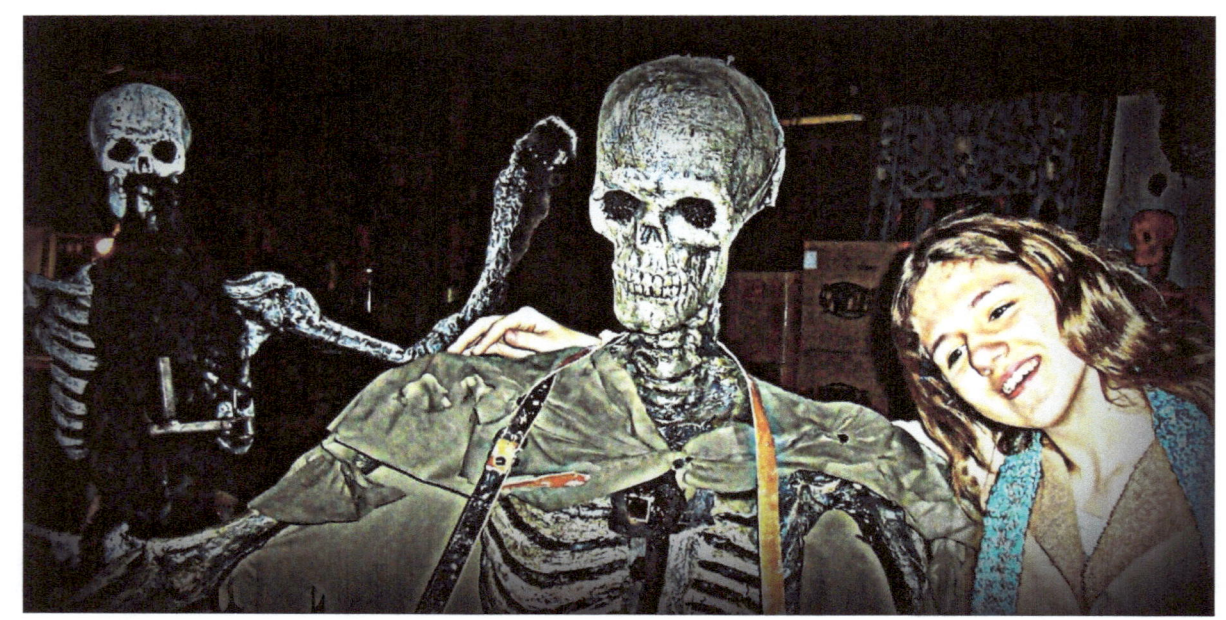

My Friend is Starving

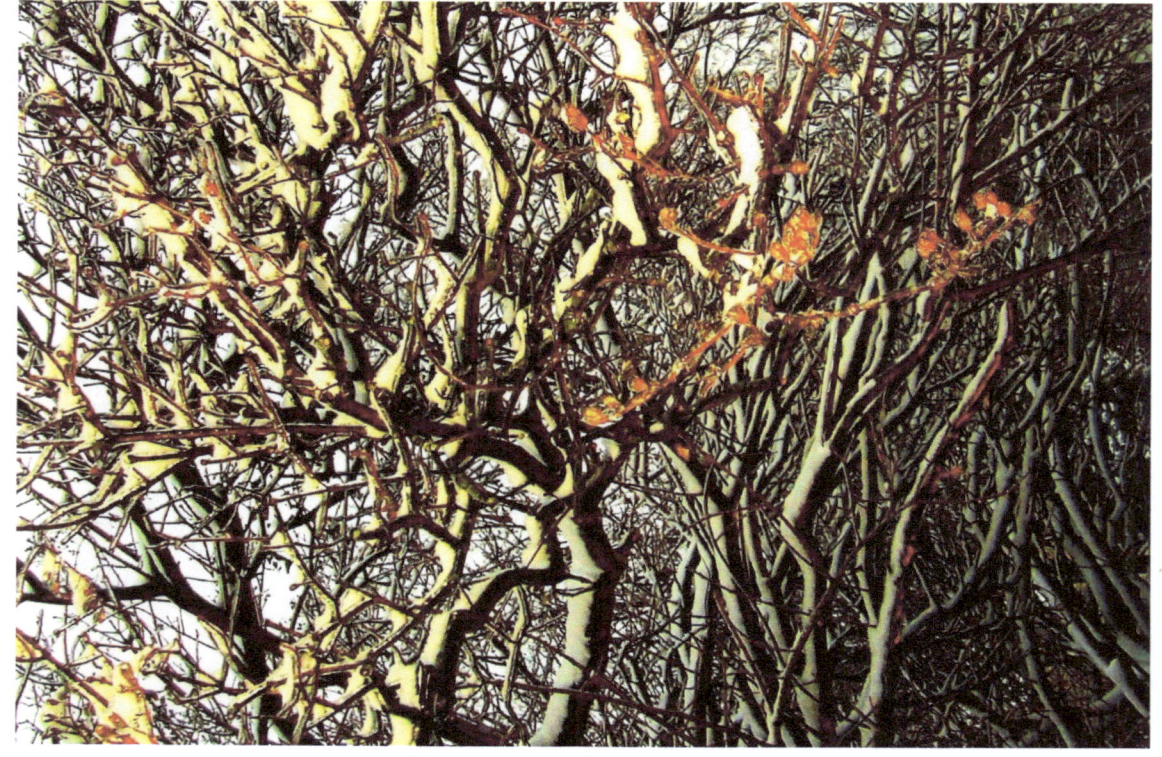

Winter Wonderland

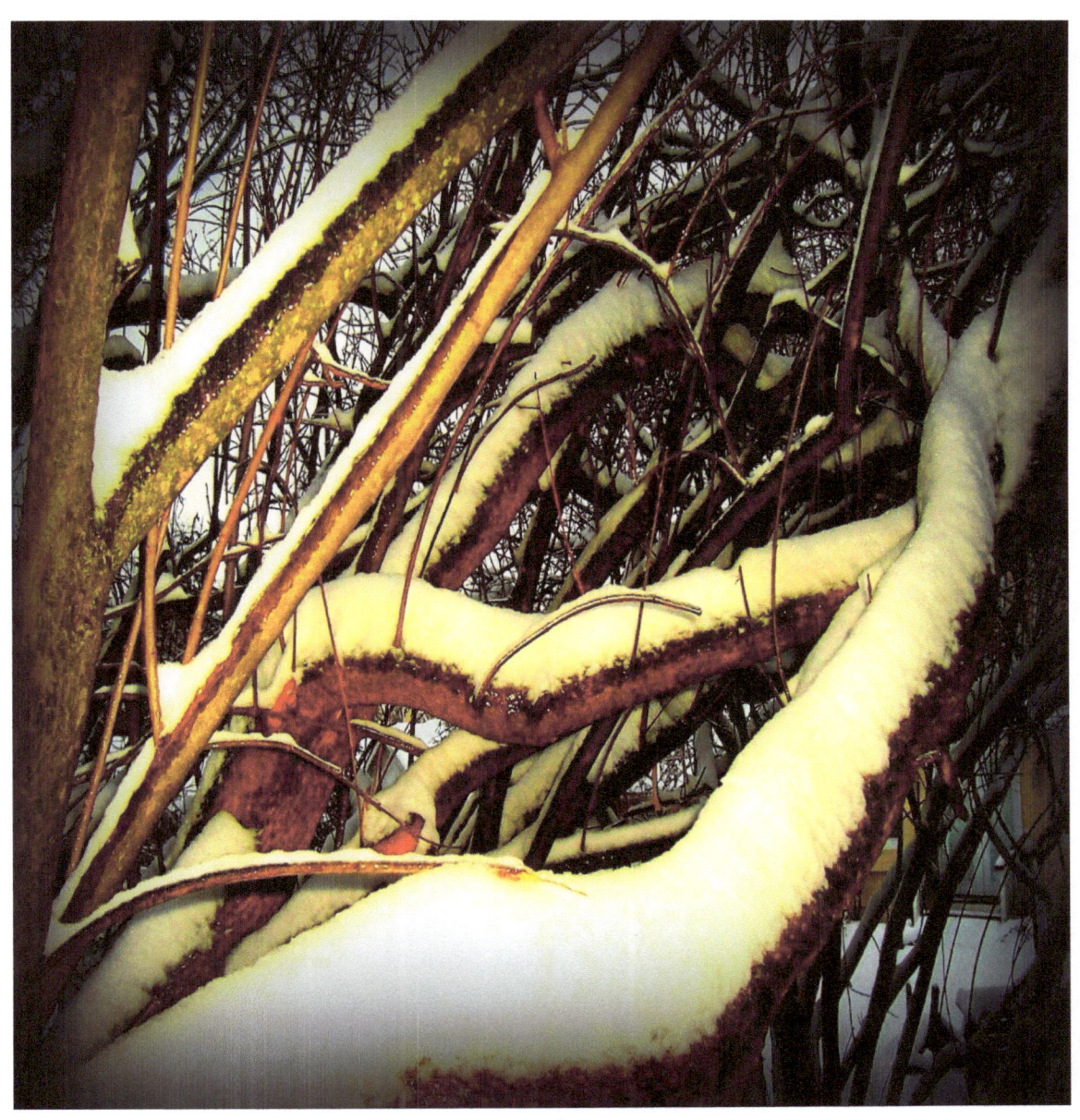

Twiggy

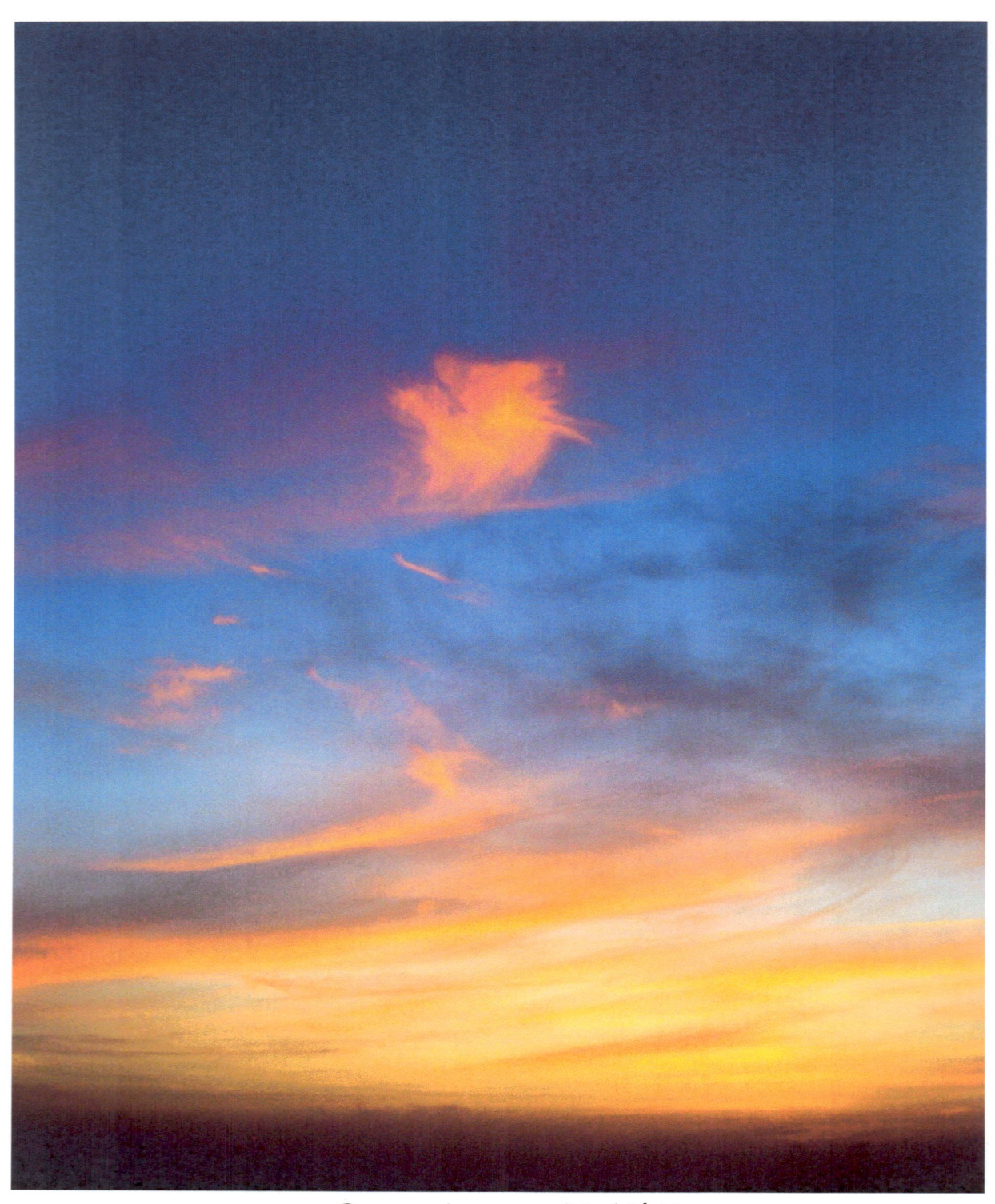
Sunset over St. Kitts

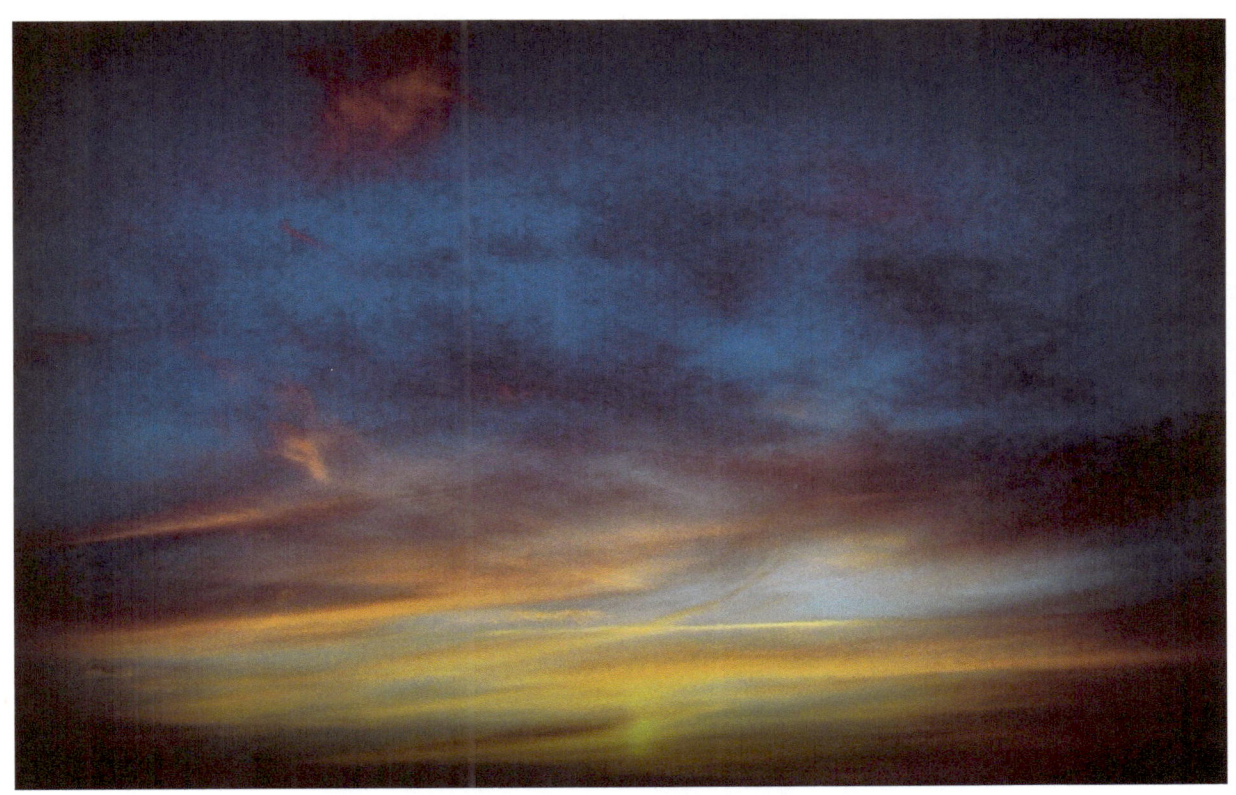

St. Kitts Sunset

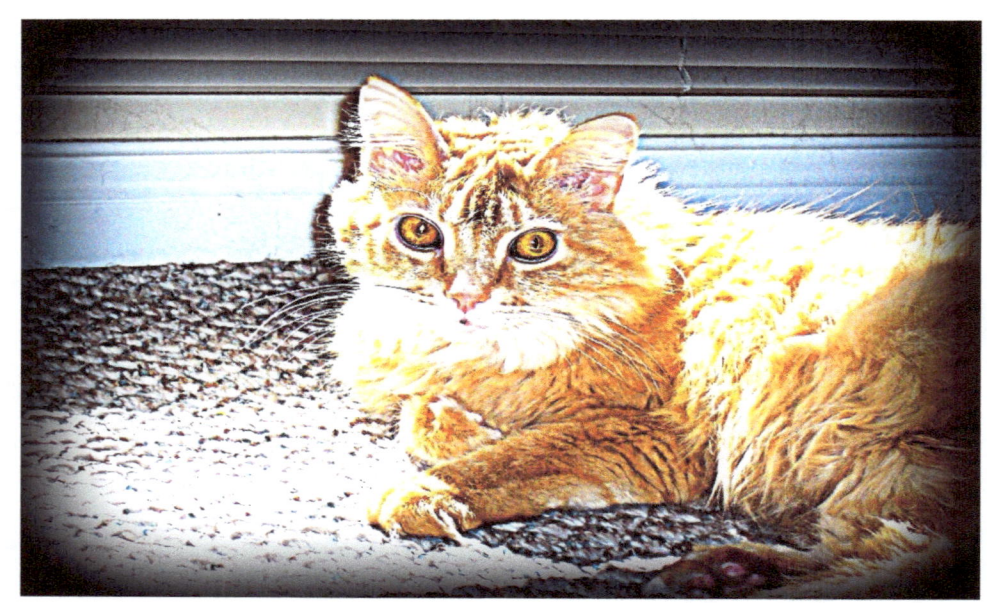

The Young Muppet

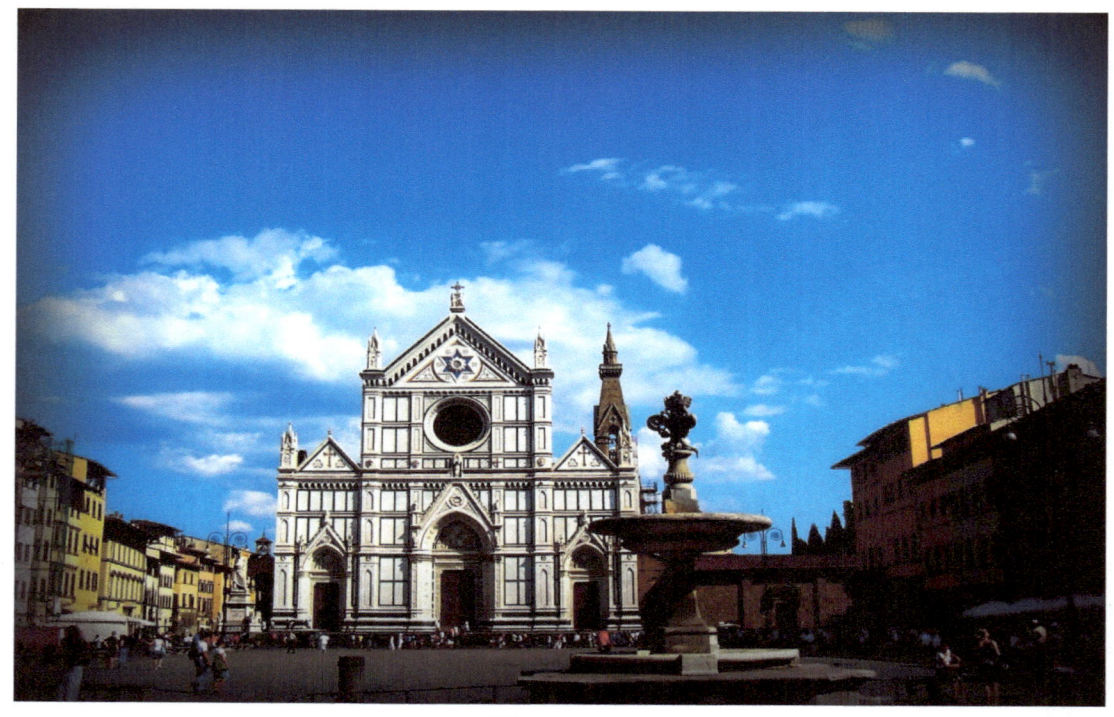

Florence

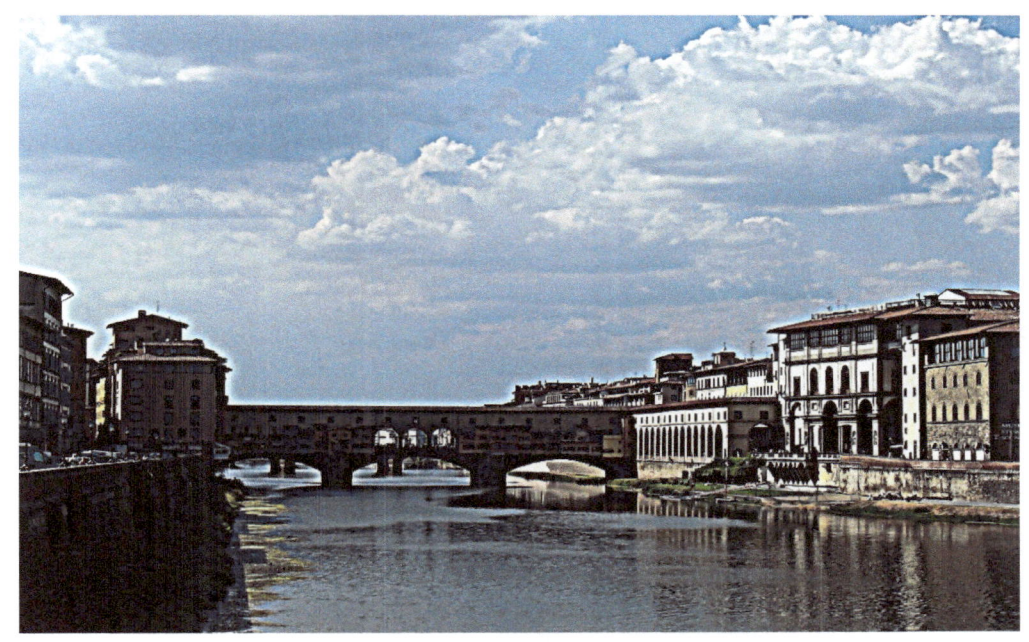

River Arno, Florence

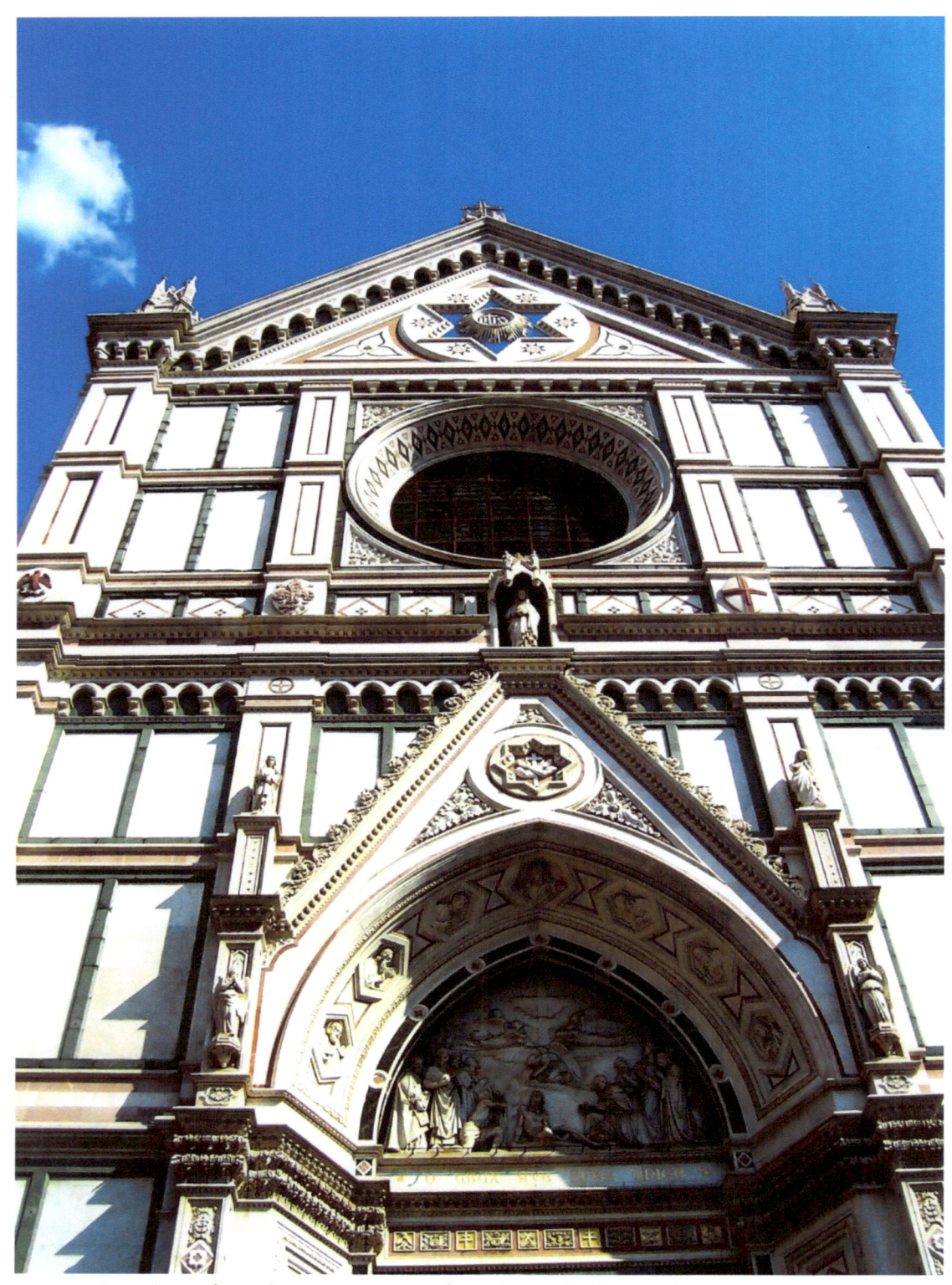
Cathedral Santa Maria del Fiore, Florence

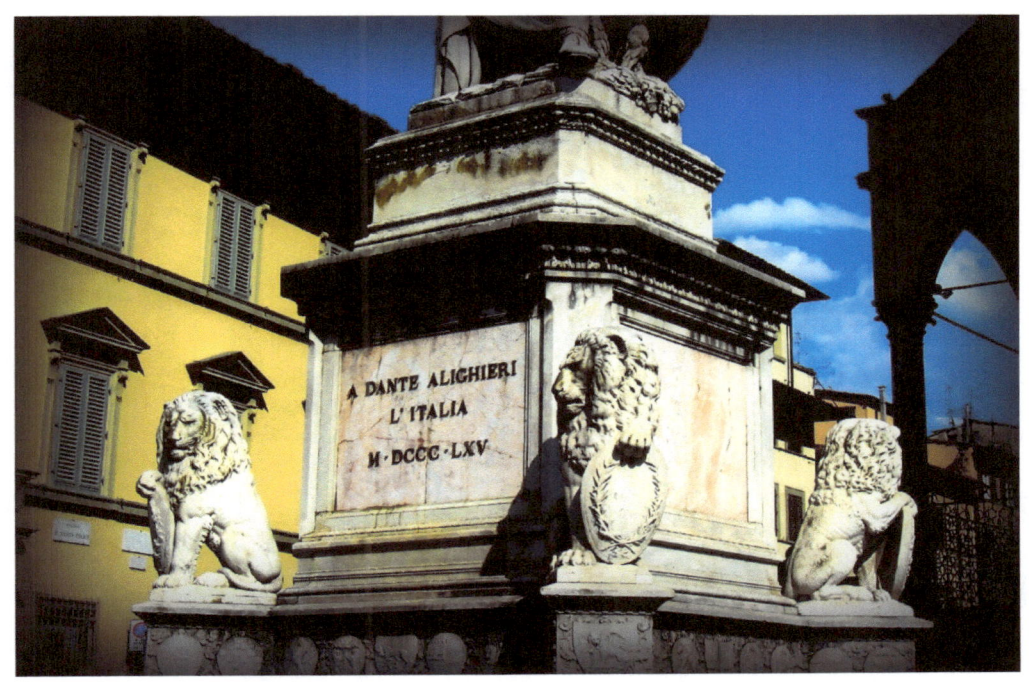

Florence

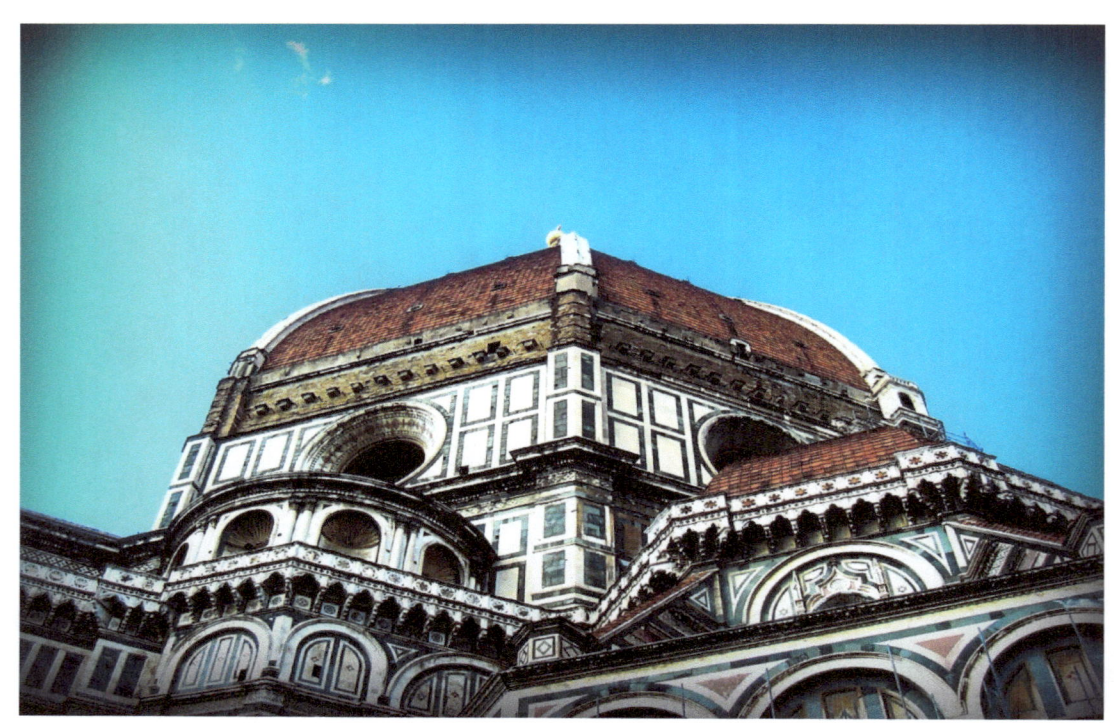
Il Duomo di Firenze

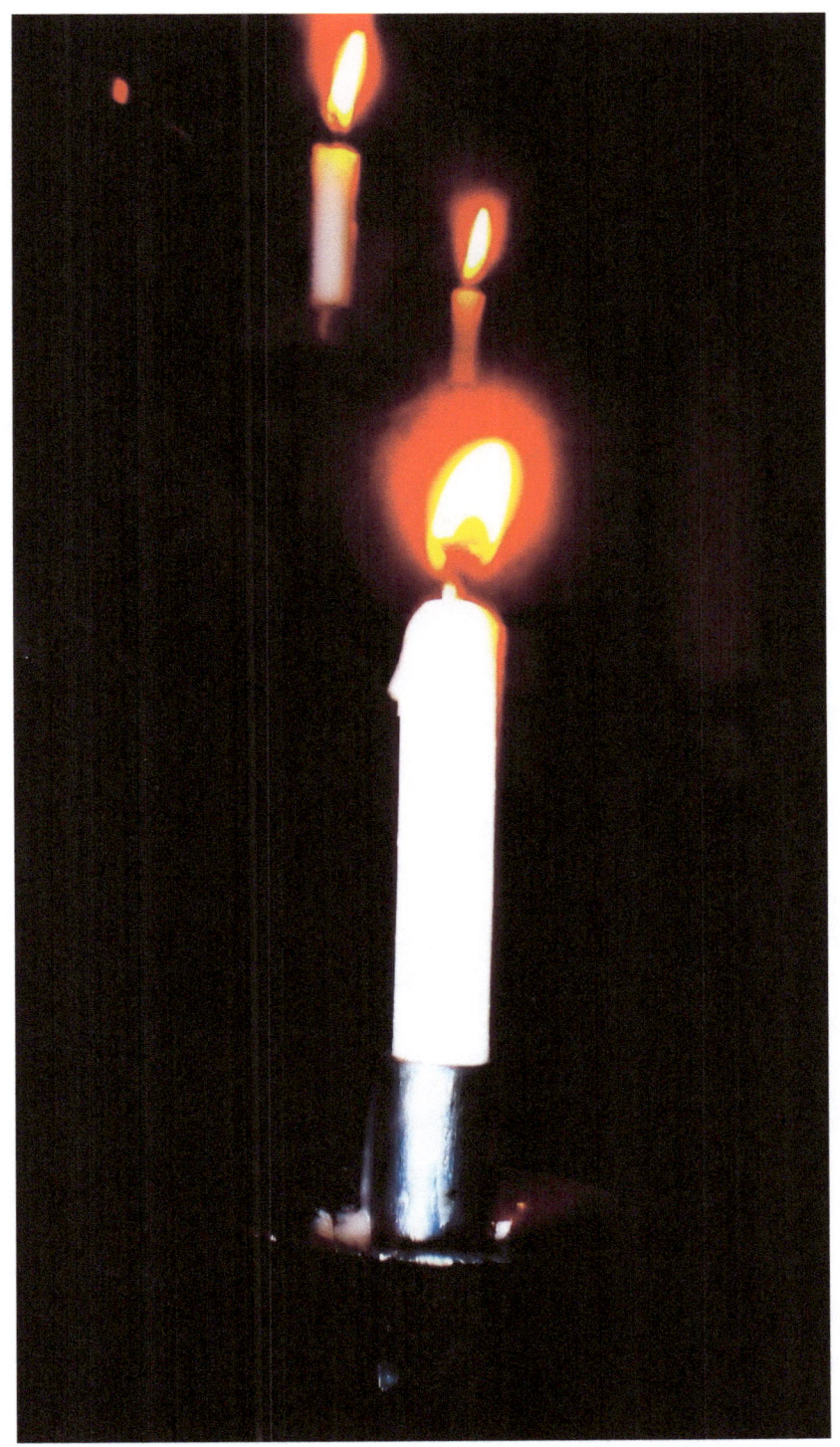

A Candle for Lady Joan, Worcester Cathedral

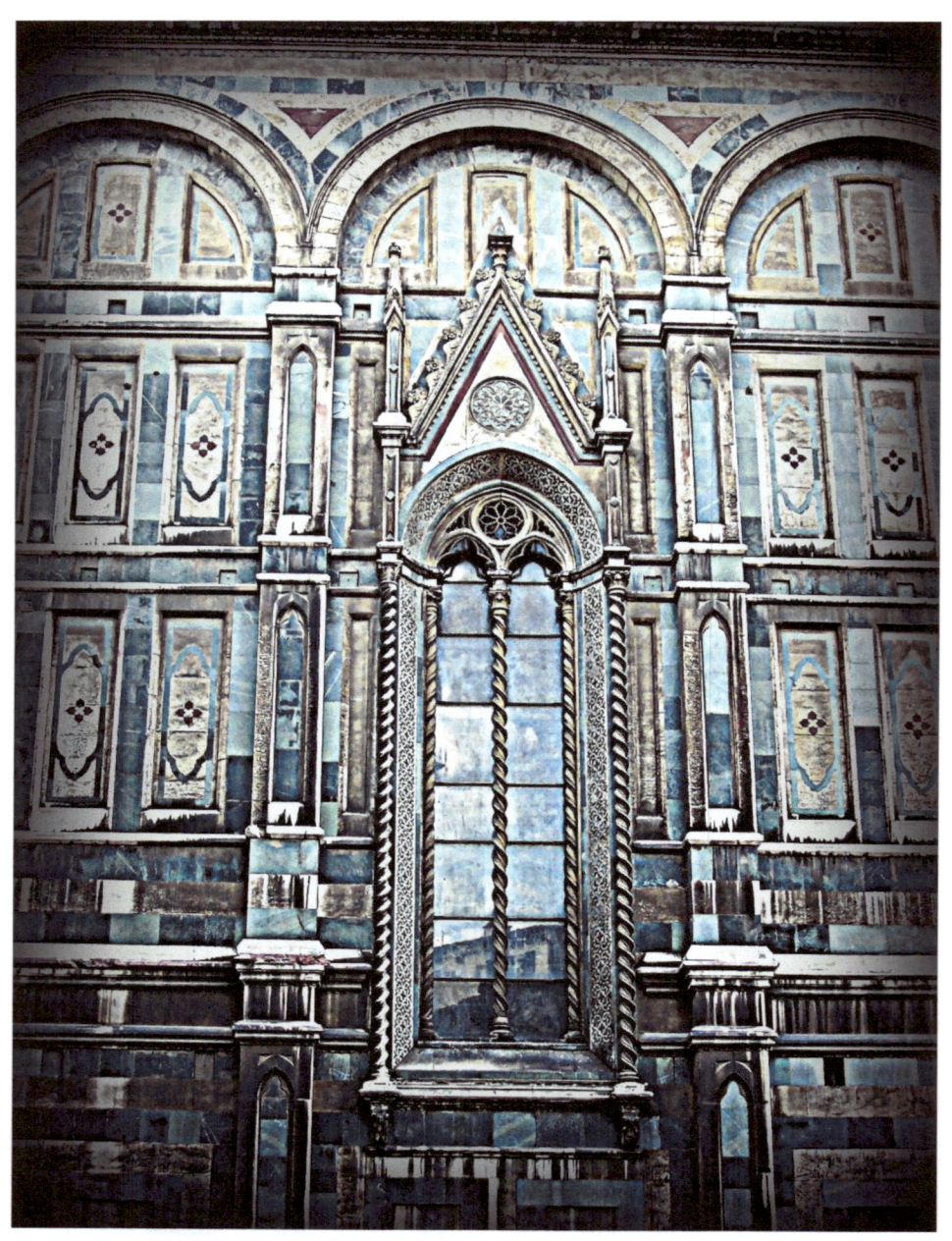
Renaissance Door, Florence

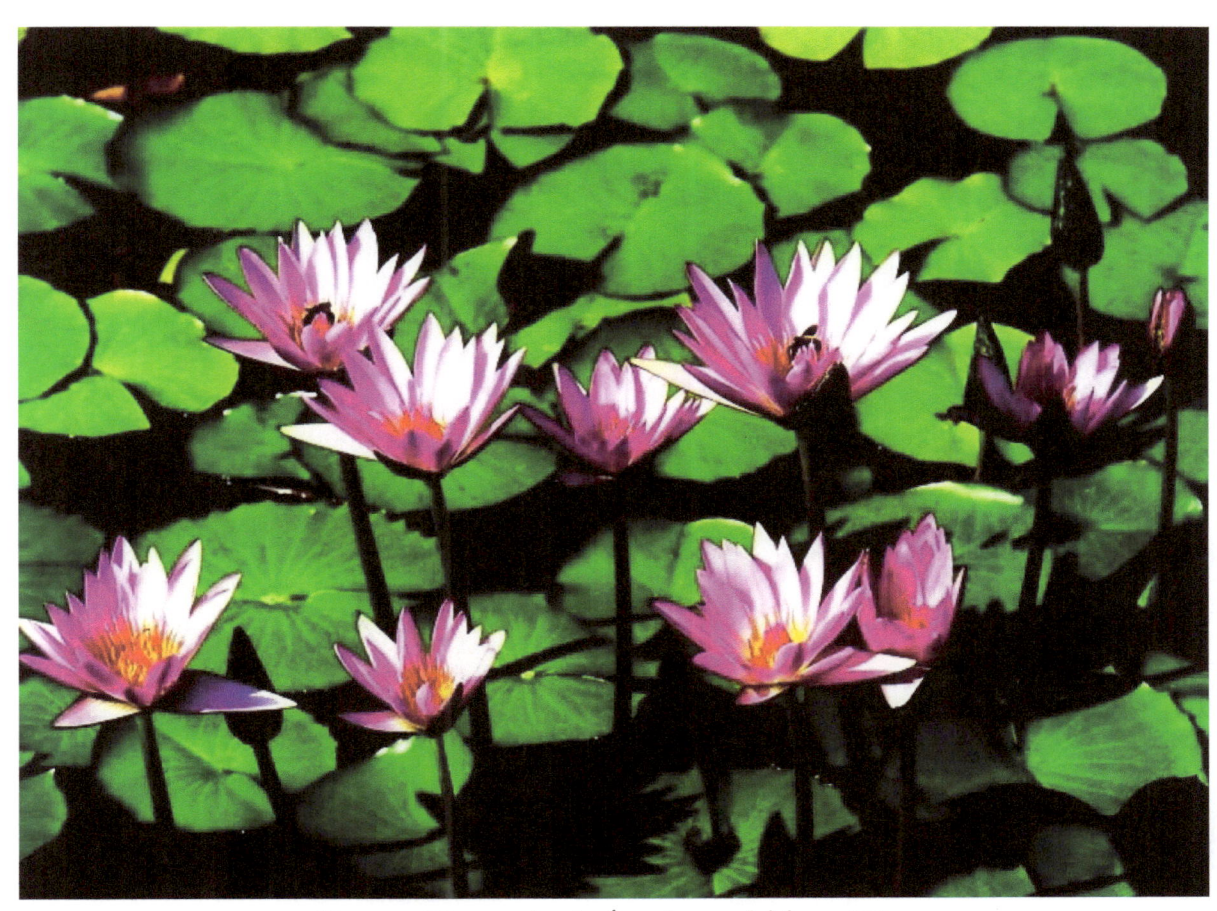

Frog Pond, Westerville Oh.

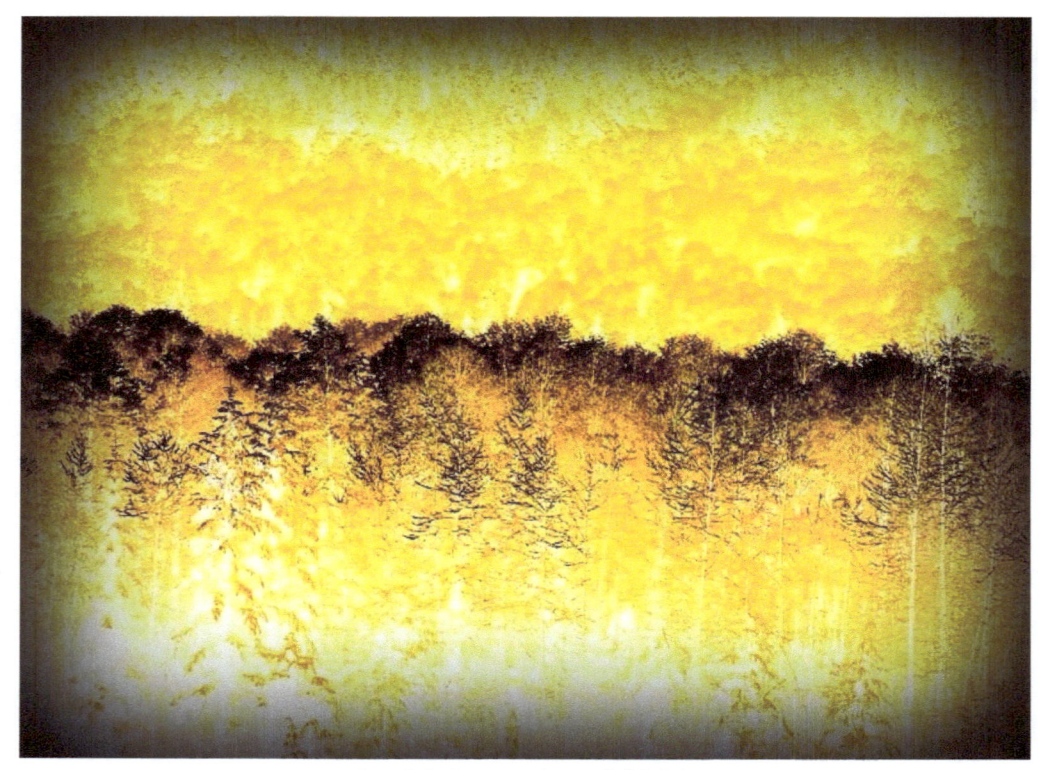
California Hills

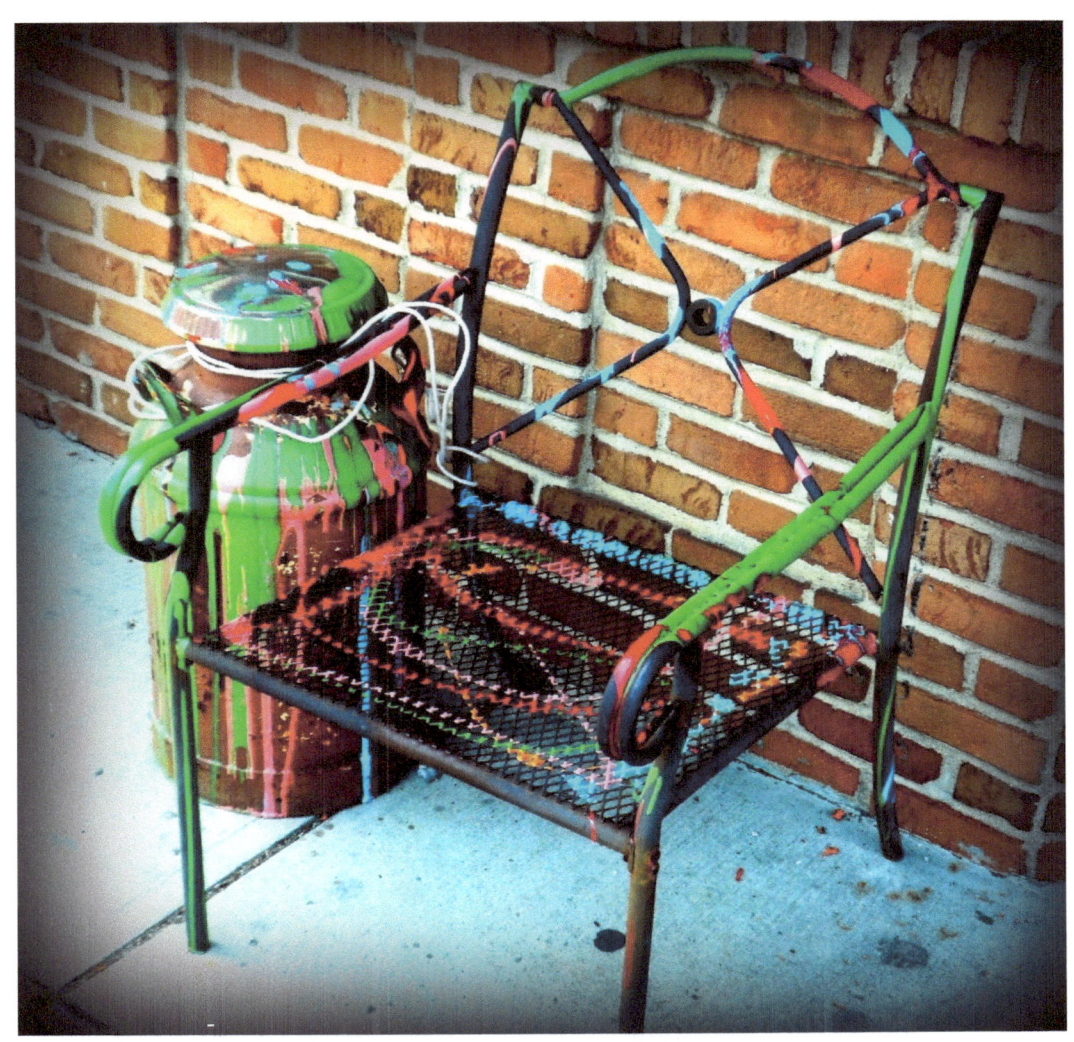
Street Art, Westerville, Oh.

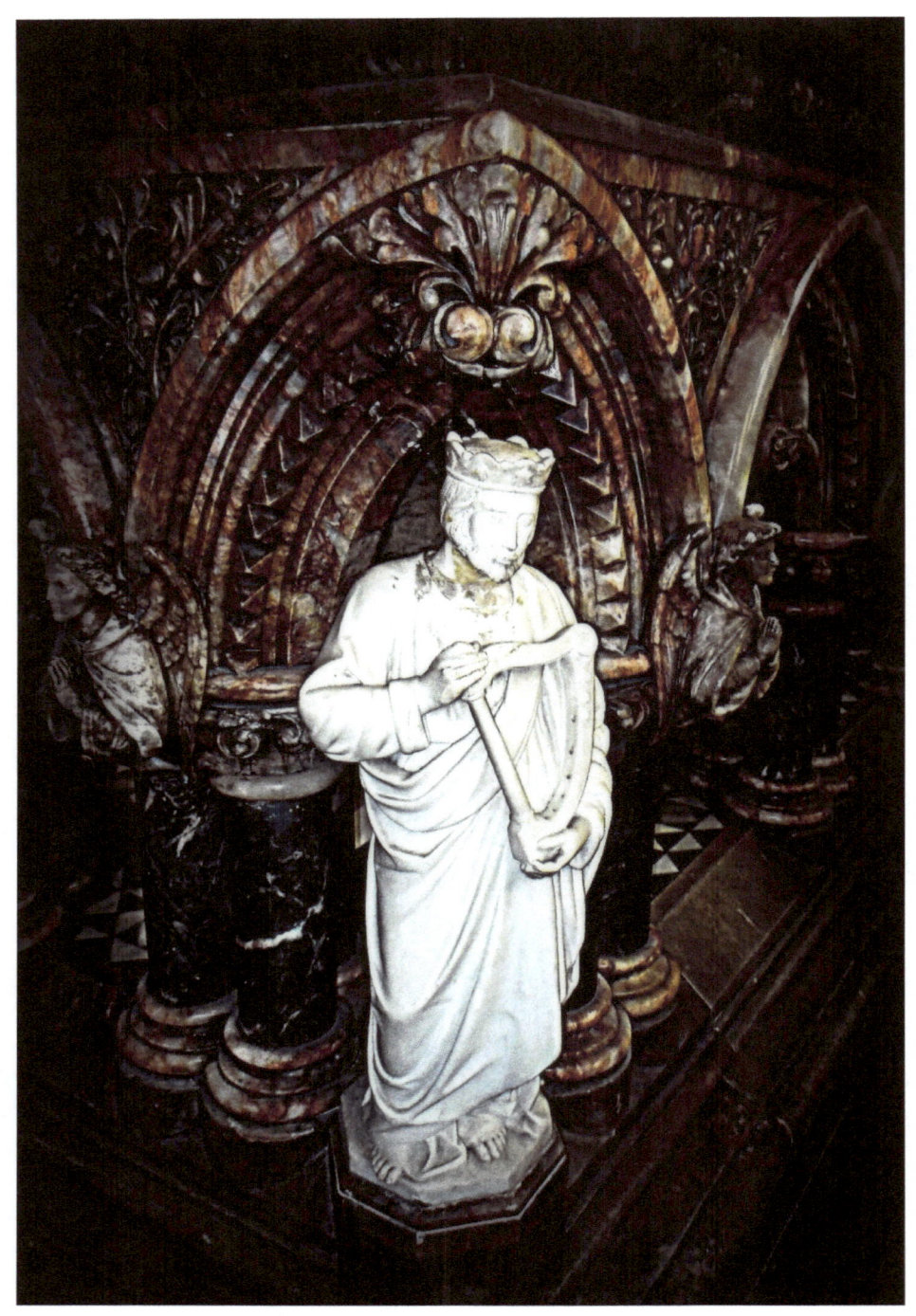
Worcester Cathedral

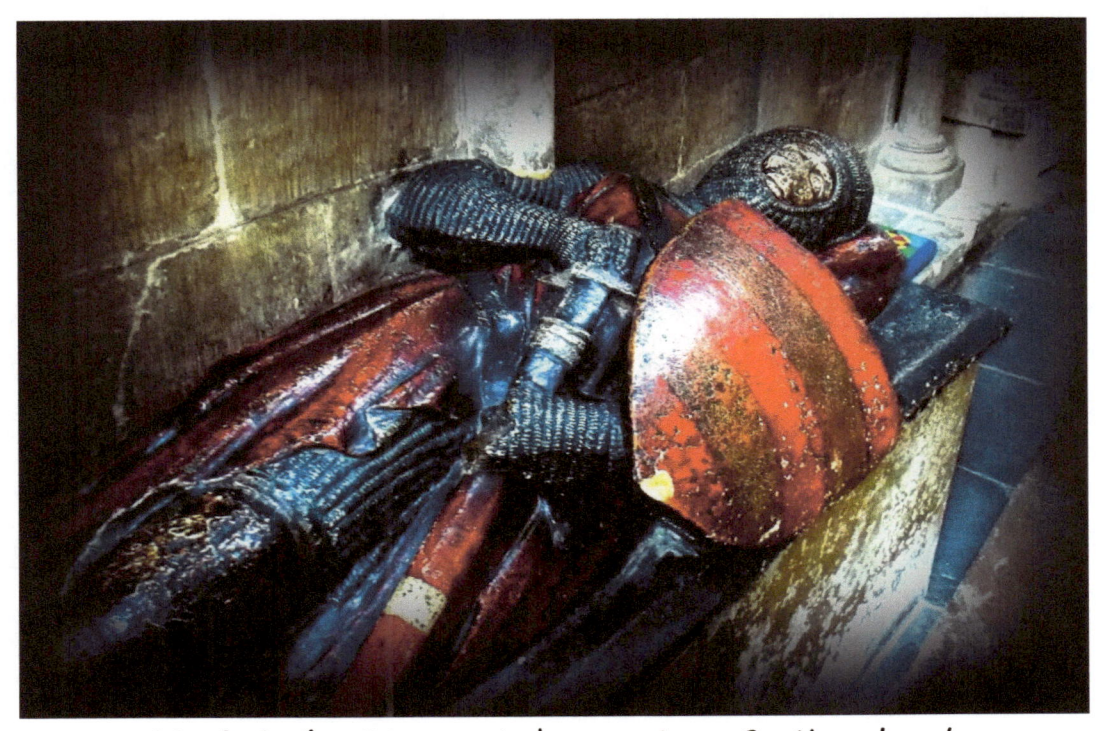

Knight's Story, Worcester Cathedral

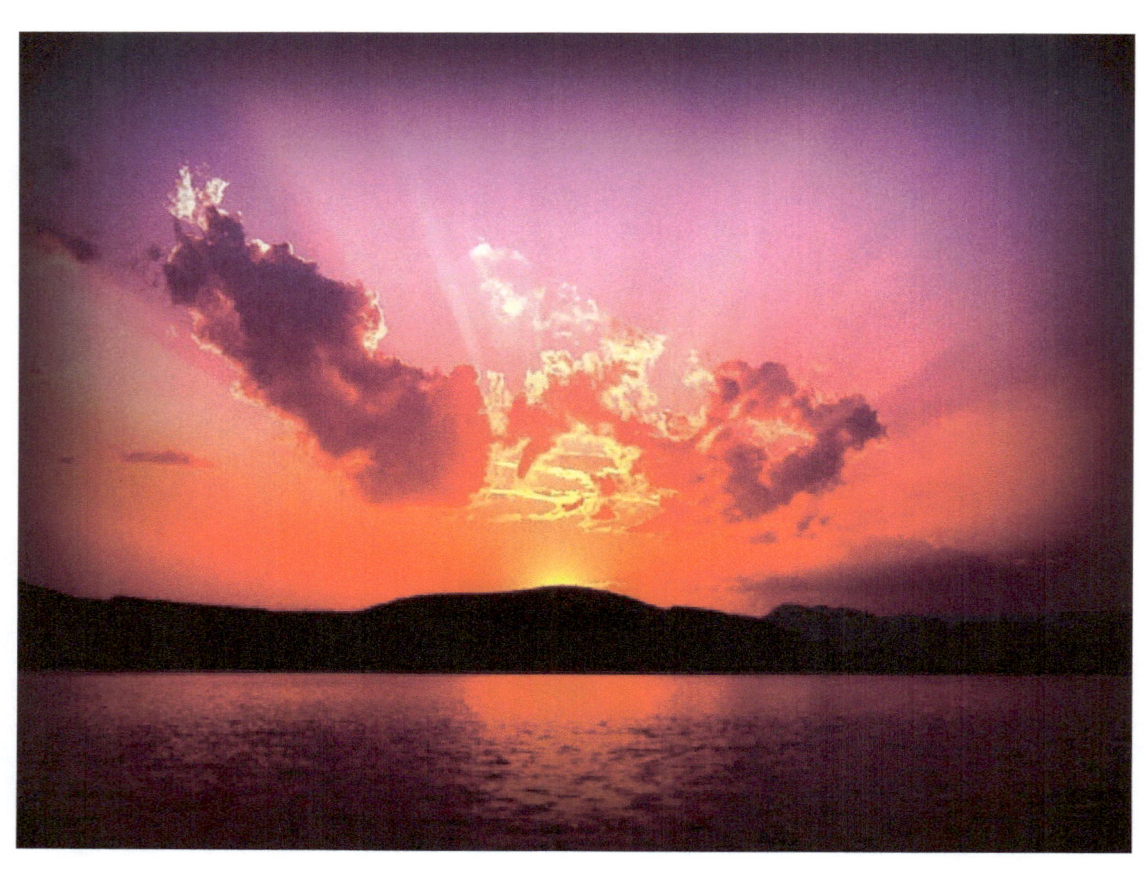

Sunset over Dominican Republic

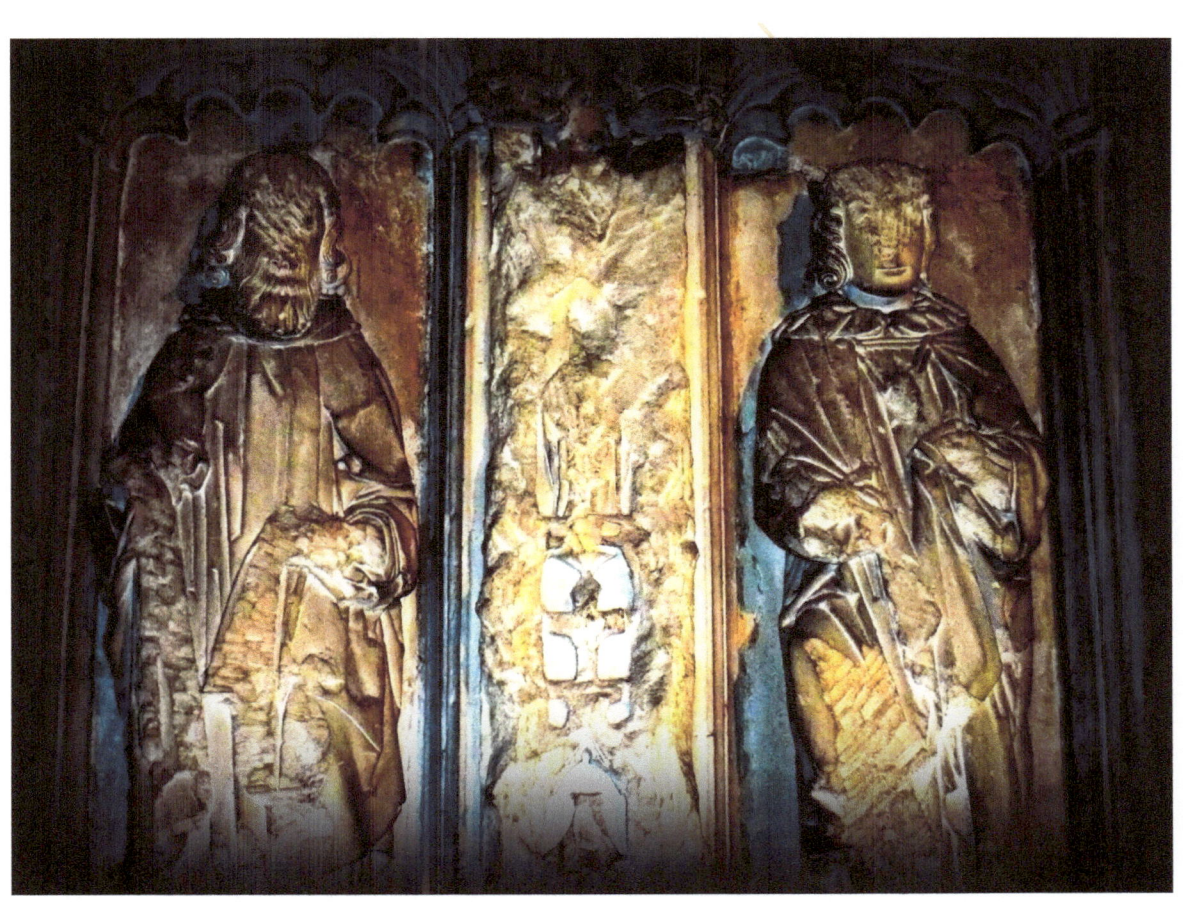

Worcester Cathedral, Tomb of Prince Arthur

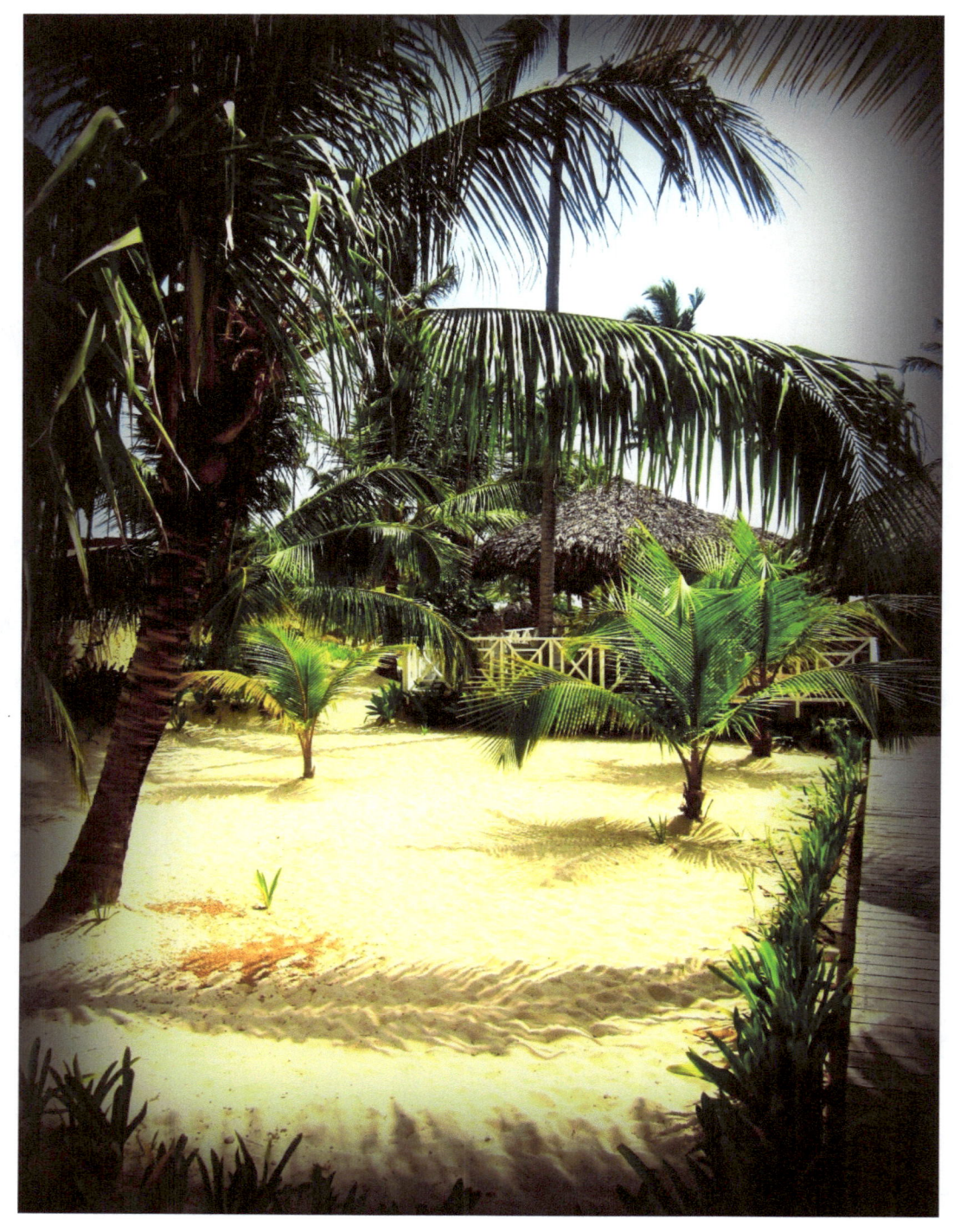

San Juan, Puerto Rico

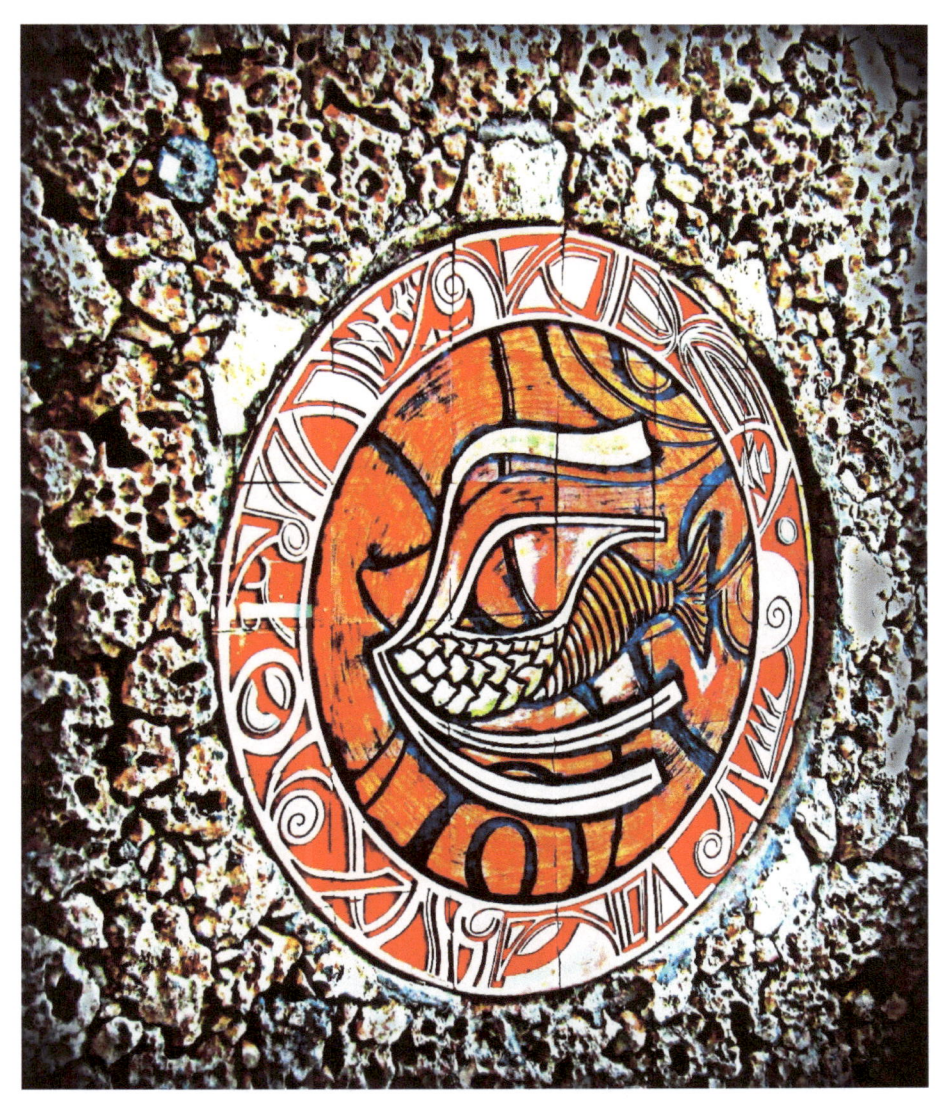

San Juan, Puerto Rico

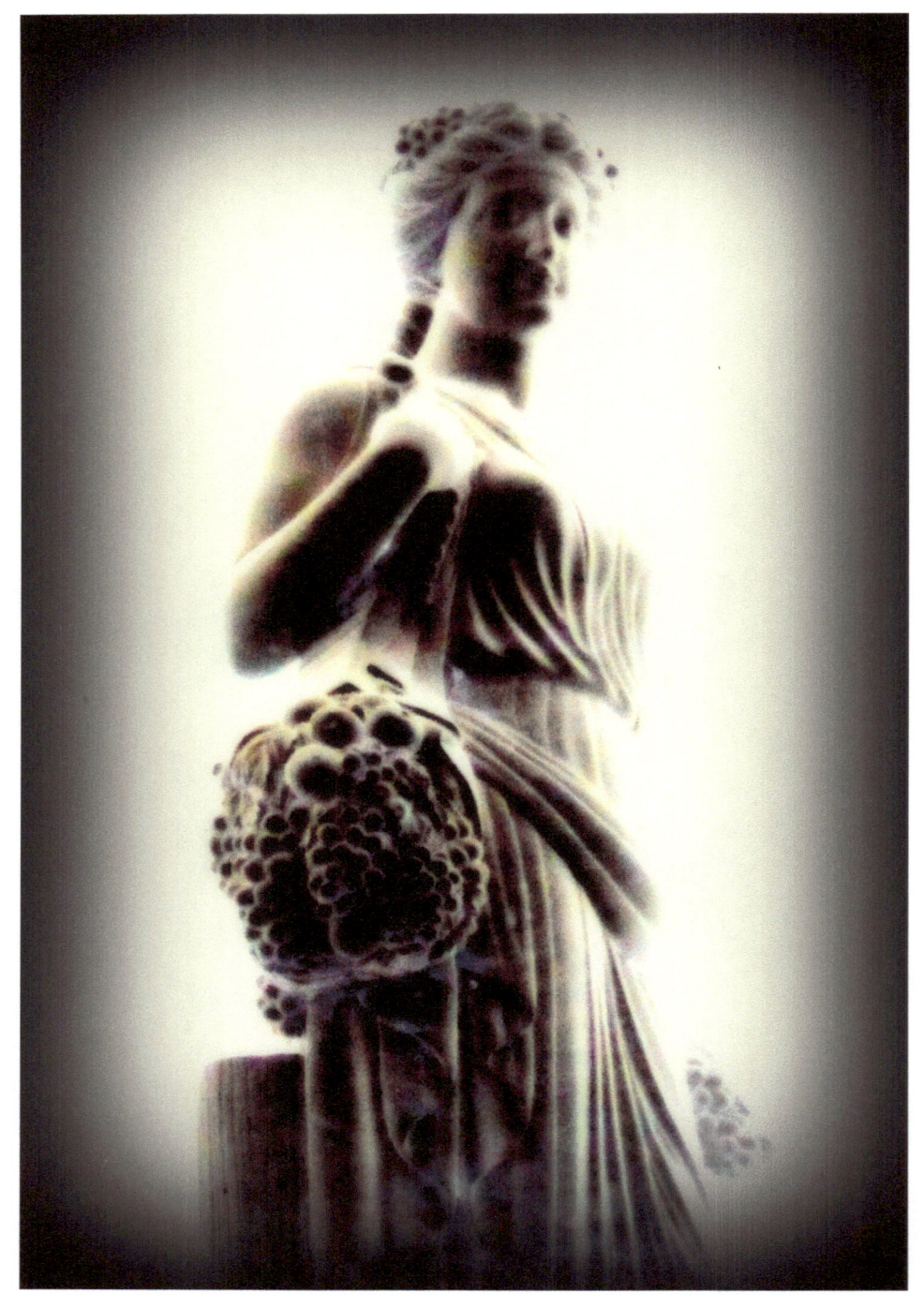

Fortuna

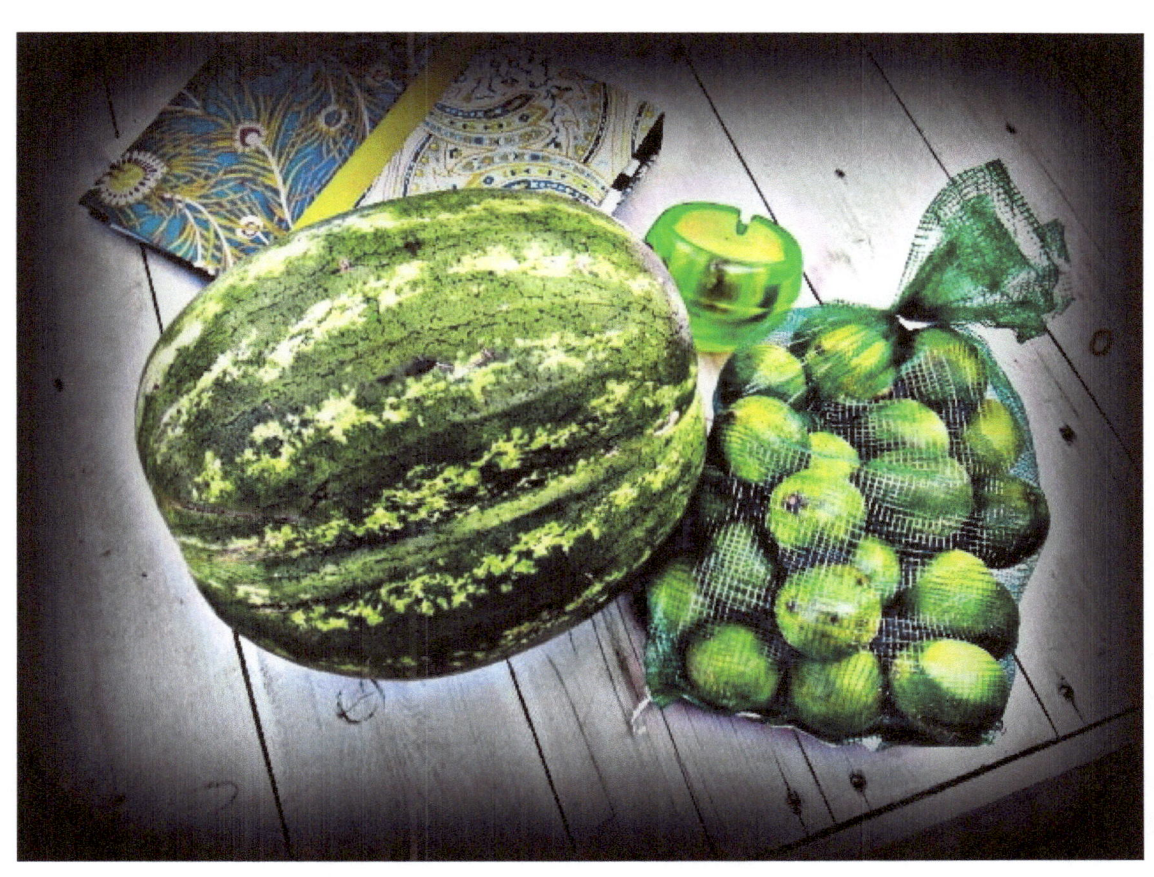

Kitchen Bitch Lemons

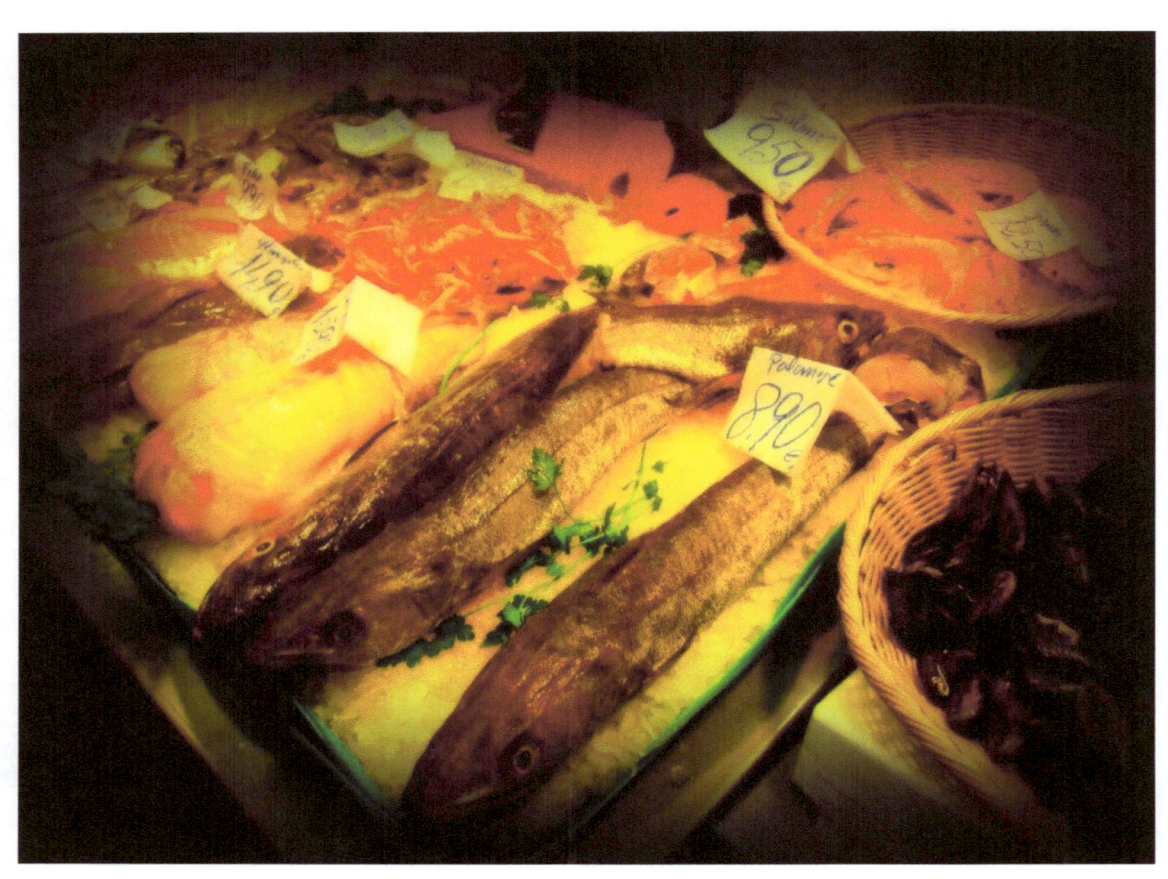

Something Fishy Here

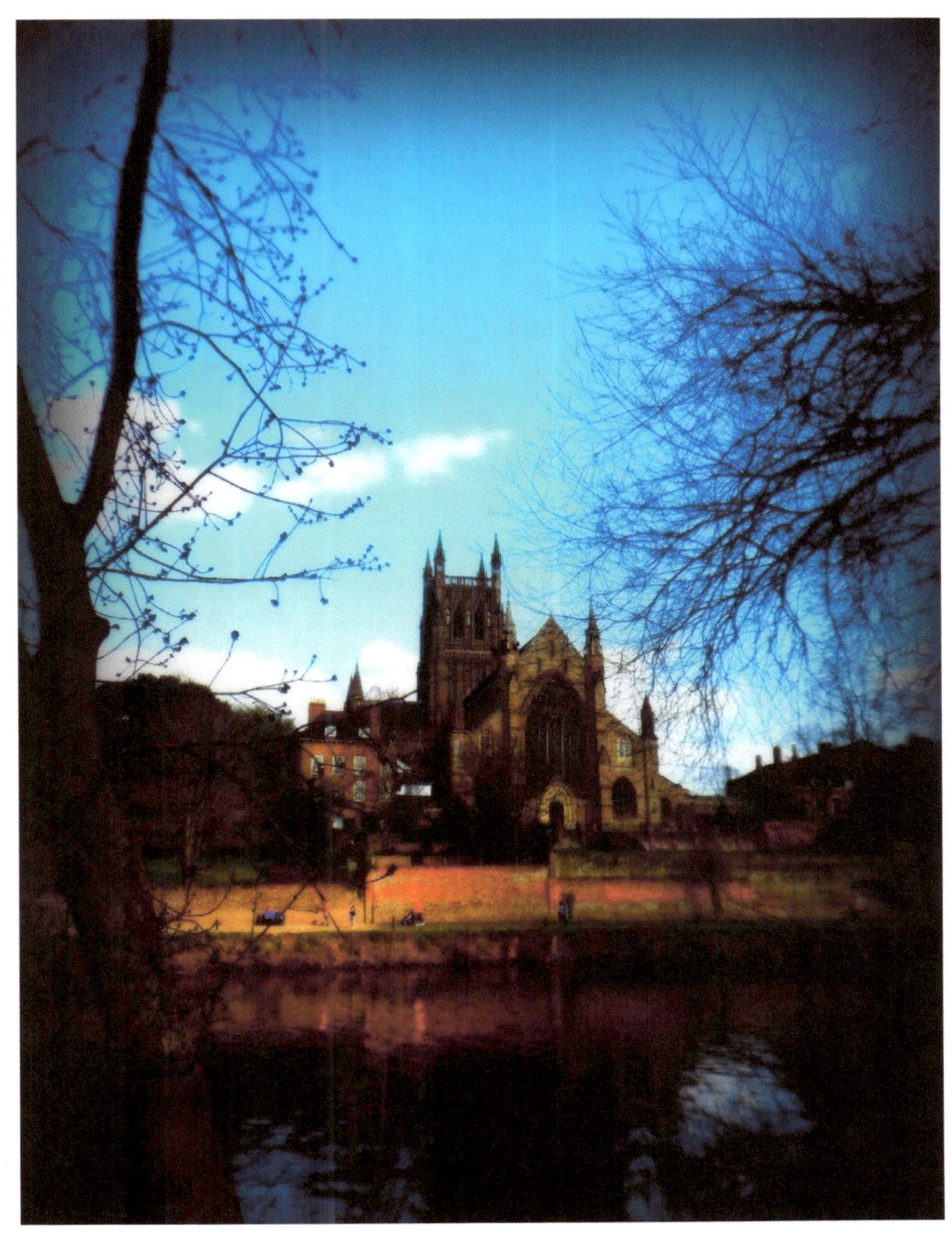

Worcester Cathedral

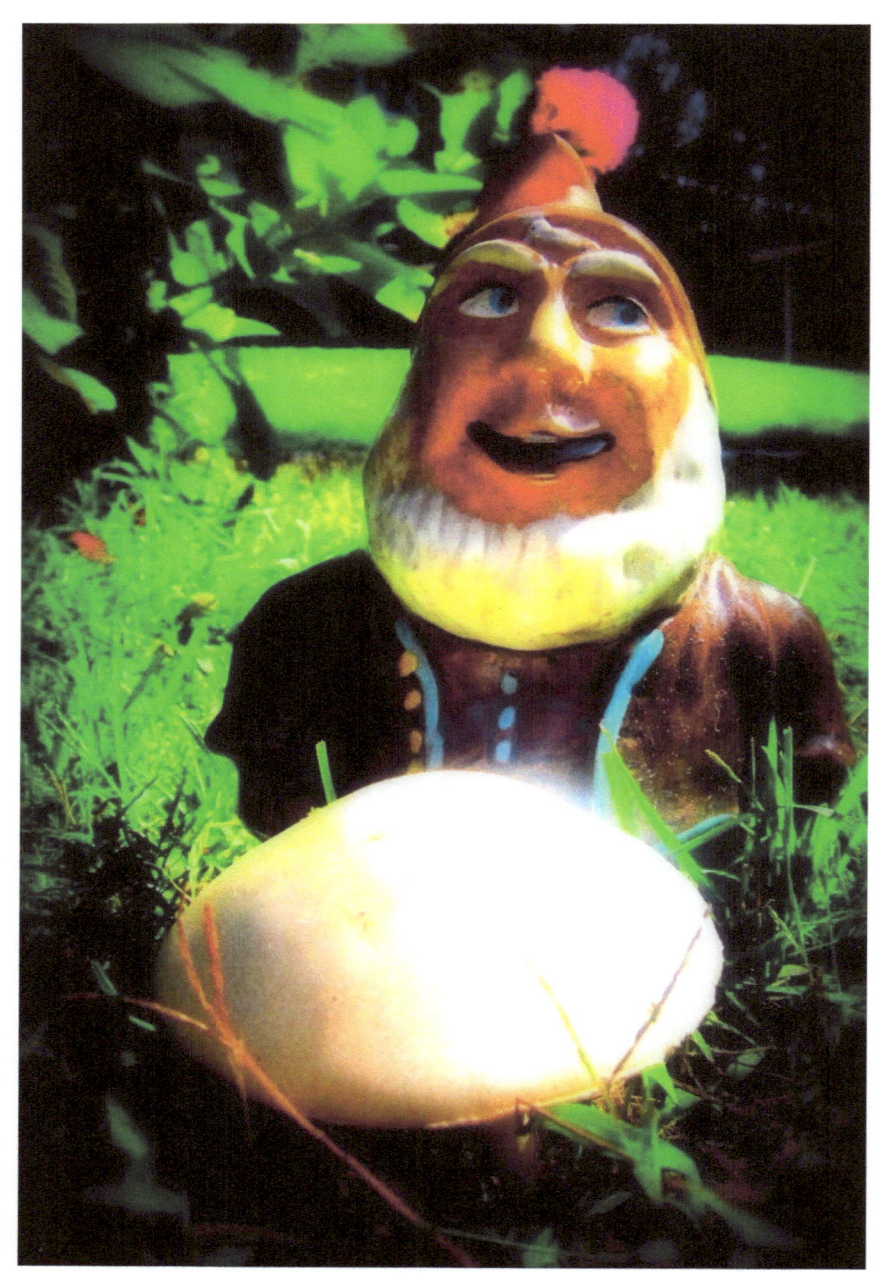

My Pal Gnomby and his Shroom

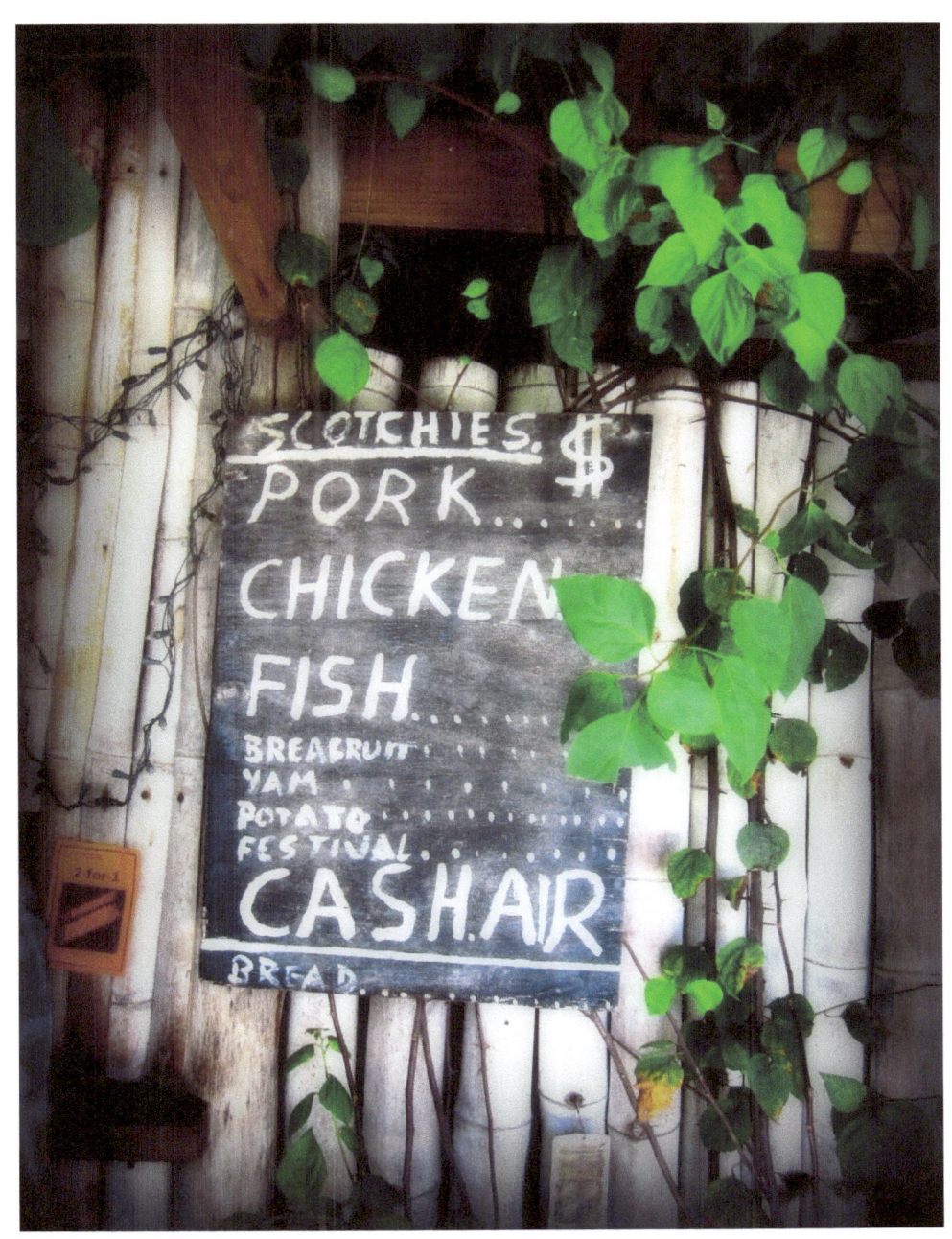

Scotchie's Bar, Jamaica

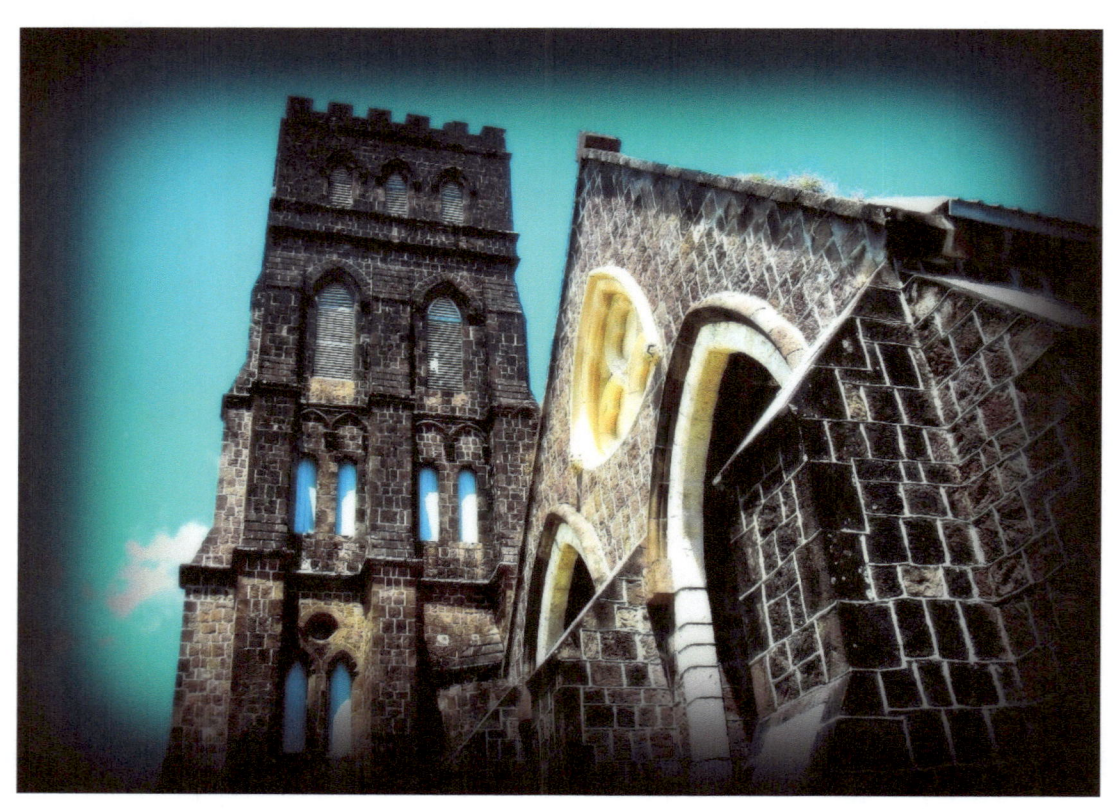

St. Thomas, Virgin Islands

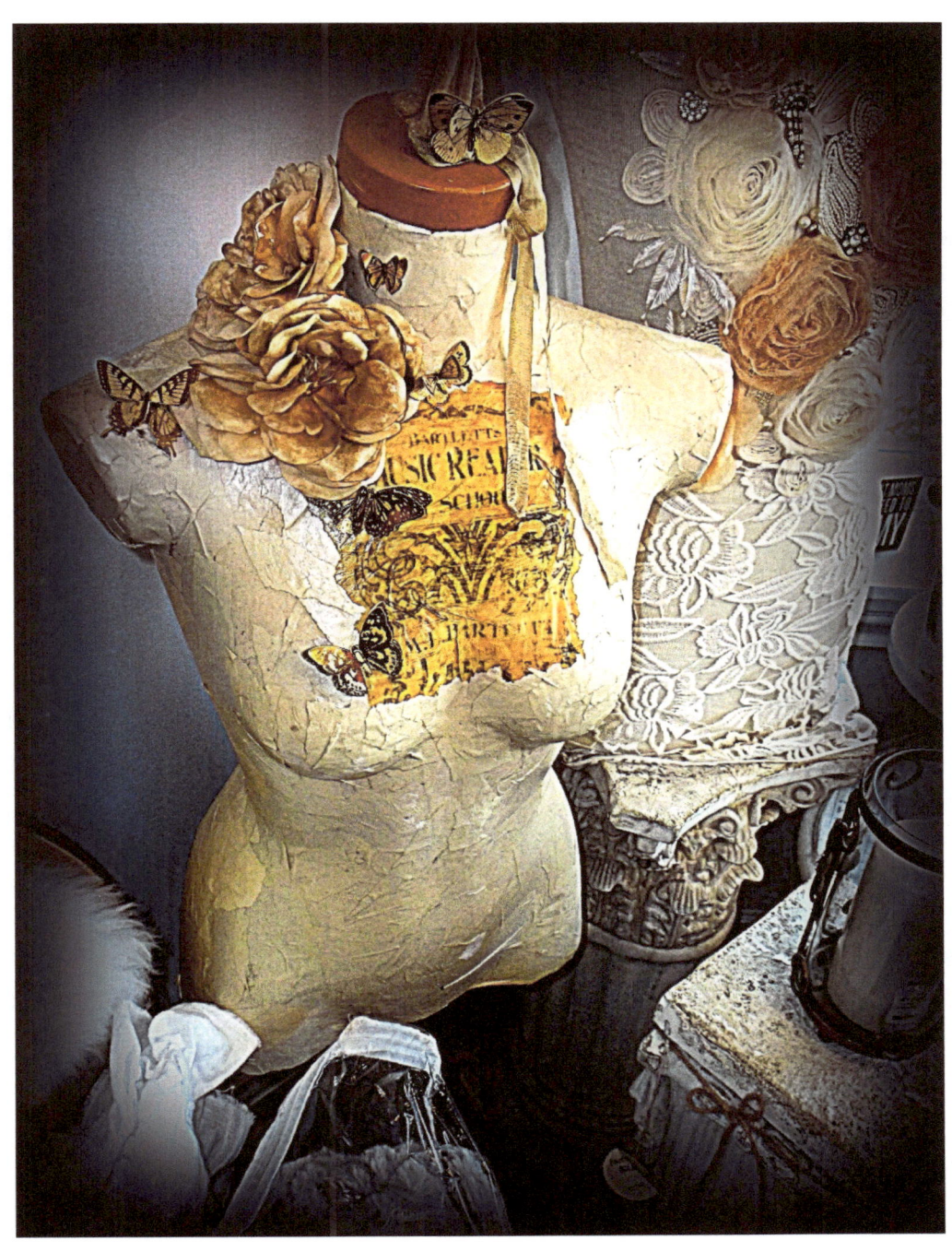

Santa Barbara, Ca. Mannequin

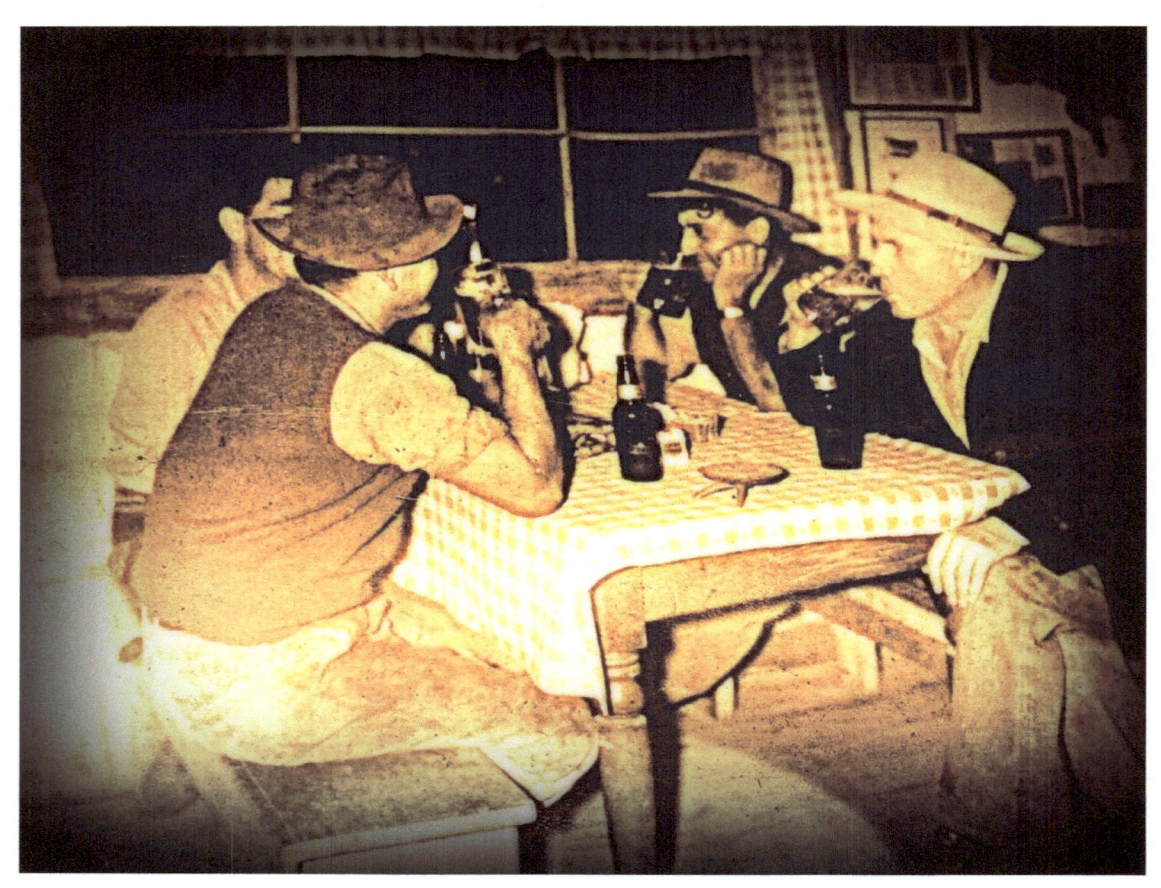

Old Timers in California

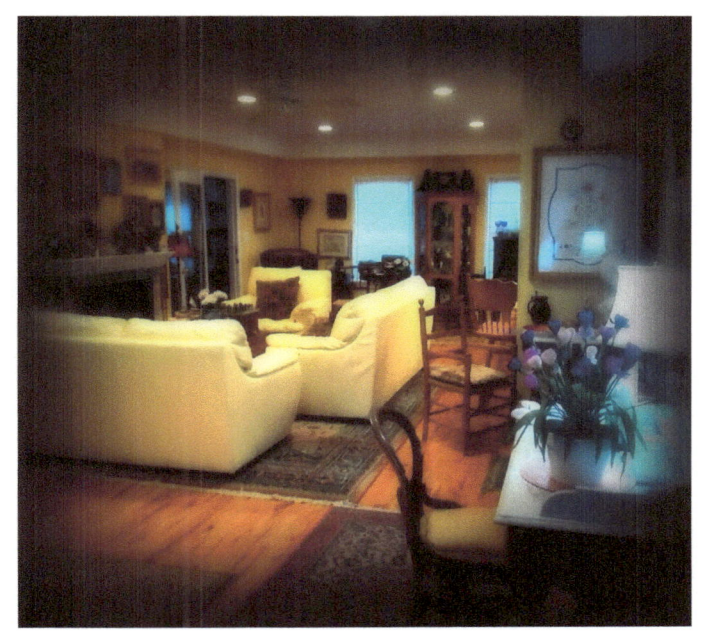

My Sitting Room I

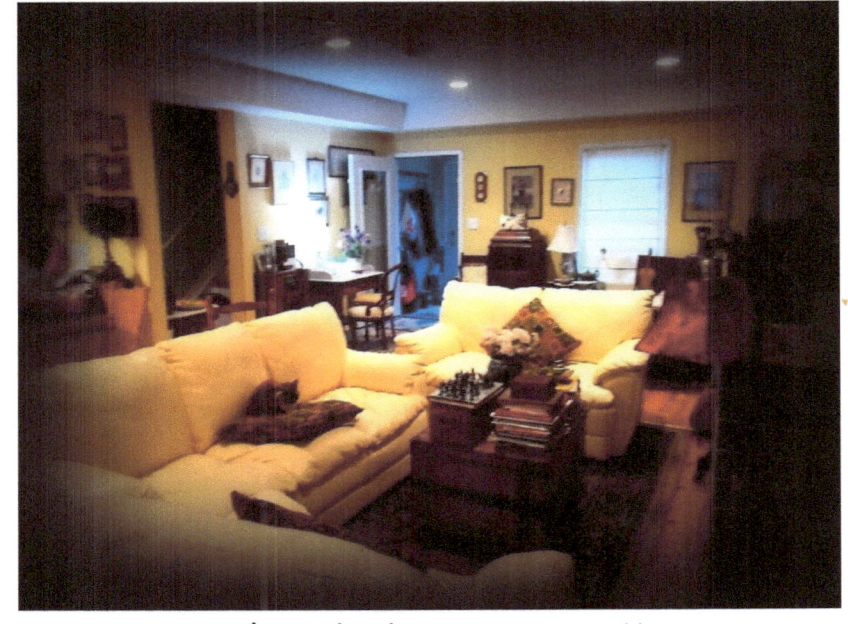

My Sitting Room II

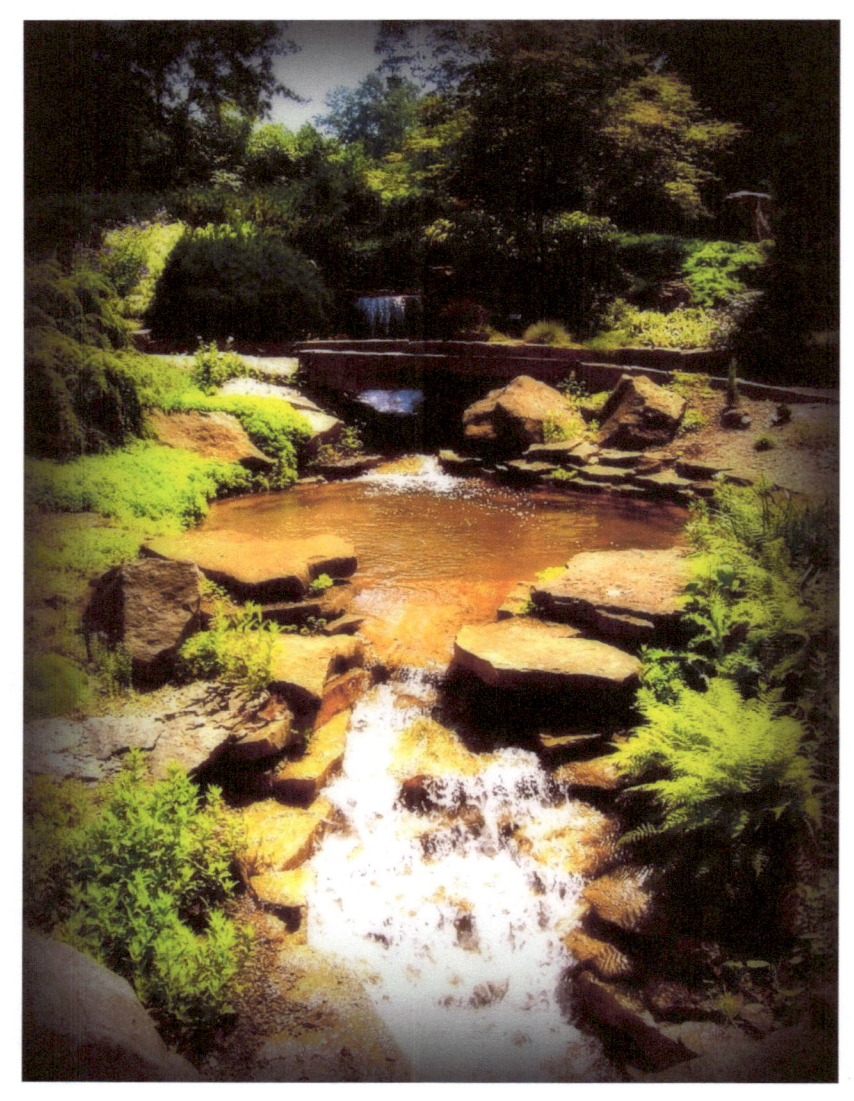

Westerville Oh, Park

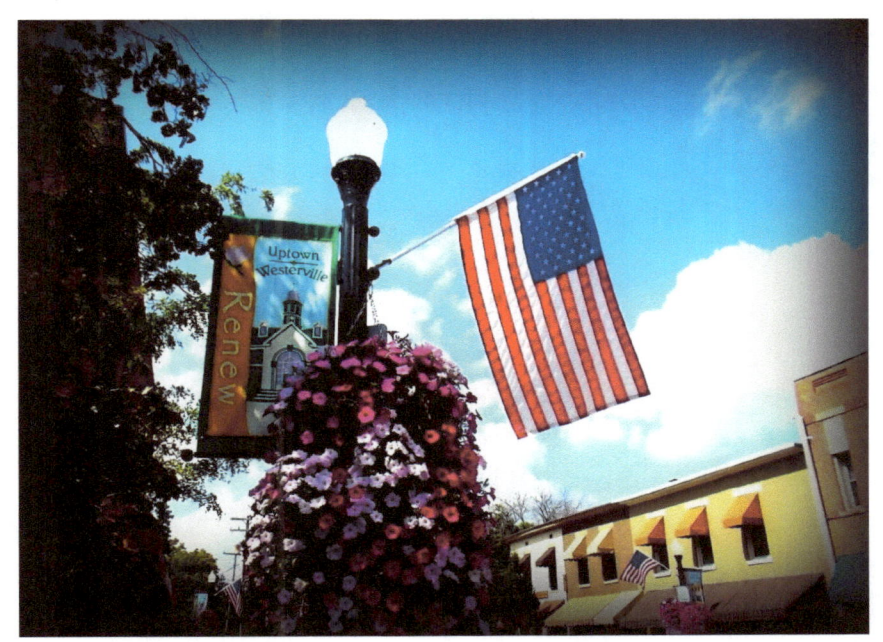

Westerville, Oh.

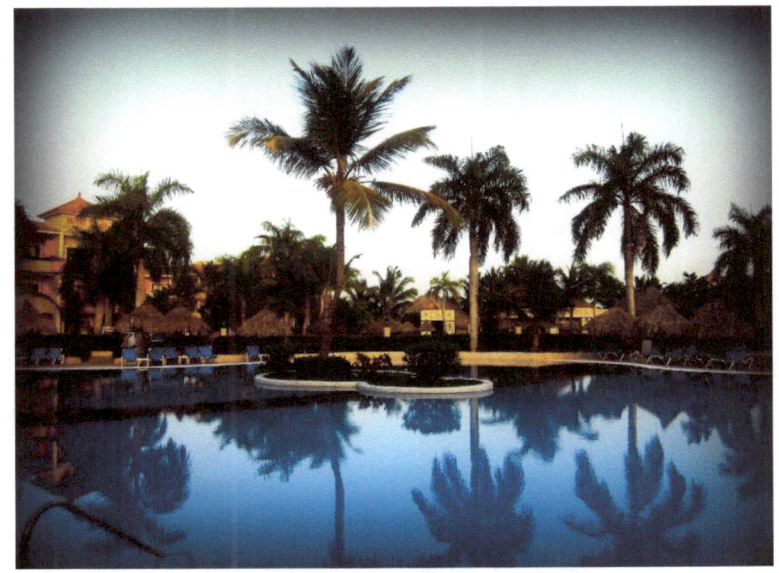

Dominican Republic

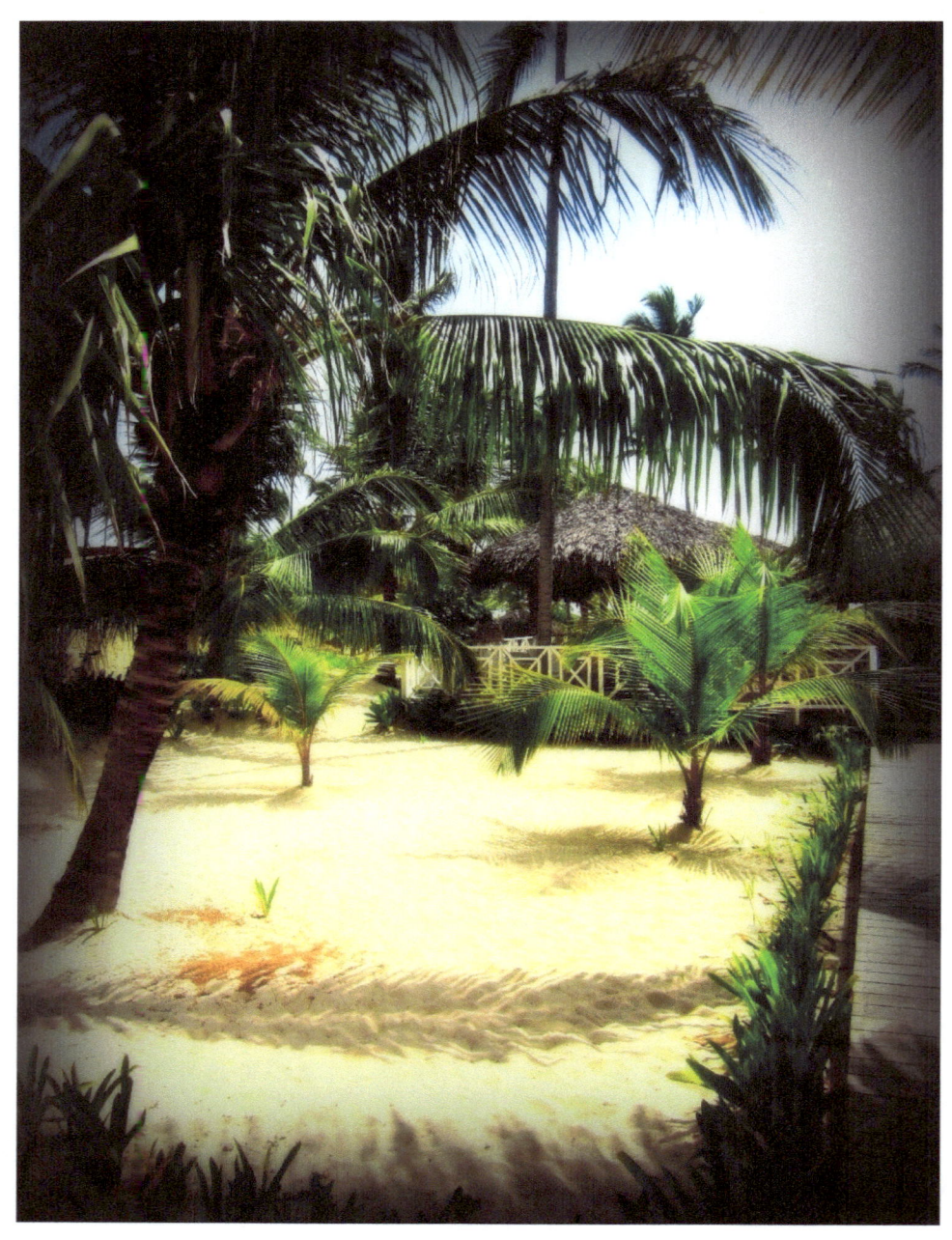

Sab Juan, Puerto Rico

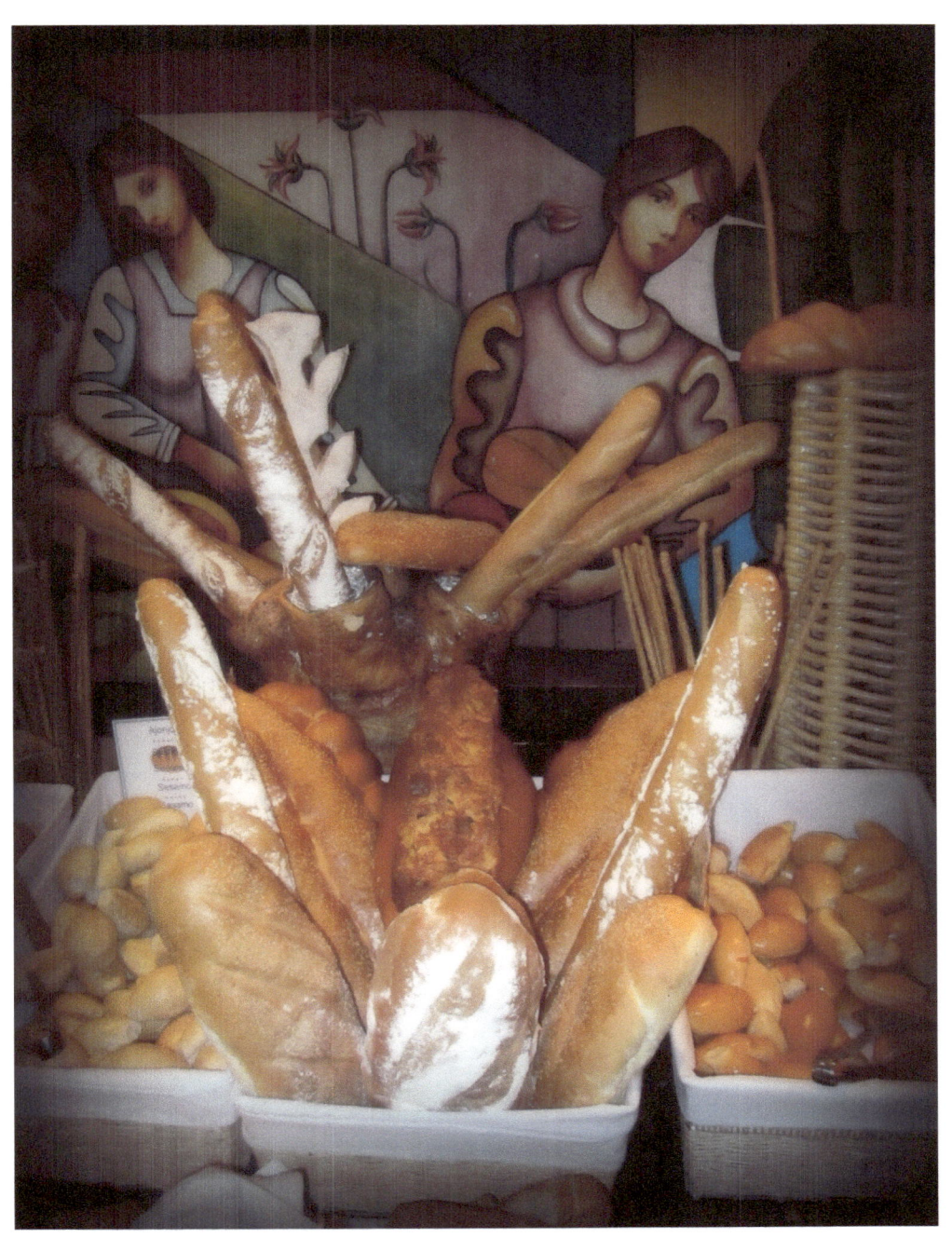

Give us this day.........

www.ingramcontent.com/pod-product-compliance
Lightning Source LLC
Chambersburg PA
CBHW051048180526
45172CB00002B/561